GLOBAL FOCUS

GLOBAL FOCUS

IMAGES OF A LAND-GRANT TRADITION

JAY A. RODMAN, EDITOR

MICHIGAN STATE UNIVERSITY PRESS • EAST LANSING

Partial funding for the production of this book was provided by the
Michigan State University Office of International Studies and Programs.

A Michigan State University Press

150

Sesquicentennial Book · 1855–2005

MICHIGAN STATE UNIVERSITY GLOBAL FOCUS

∞ The paper used in this publication meets the minimum requirements
of ANSI/NISO Z39.48-1992 (R 1997) (Permanence of Paper).

Michigan State University Press
East Lansing, Michigan 48823-5245
Printed and bound in China.

11 10 09 08 07 06 05 1 2 3 4 5 6 7 8 9 10

LIBRARY OF CONGRESS CATALOGING-IN-PUBLICATION DATA
Global focus : images of a land-grant tradition / edited by Jay A. Rodman.
p. cm.
Includes bibliographical references.
ISBN 0-87013-761-1 (cloth : alk. paper)
1. Photography, Artistic. 2. Travel photography. 3. Photography—Competitions—Michigan—East Lansing.
4. Michigan State University. Office of International Studies and Programs. I. Rodman, Jay A.
TR654.G585 2005
779—dc22
2005016470

Cover and book design by Sharp Designs, Lansing, MI.
Cover photograph: "City Wall," by Donald Roberts.

green press INITIATIVE Michigan State University Press is a member of the Green Press Initiative
and is committed to developing and encouraging ecologically responsible
publishing practices. For more information about the Green Press Initiative and the use of
recycled paper in book publishing, please visit *www.greenpressinitiative.org*.

Visit Michigan State University Press on the World Wide Web at *www.msupress.msu.edu*

CONTENTS

Michigan State University's sesquicentennial offers us the opportunity to reflect on our rich heritage as the pioneering land-grant university, to celebrate the path-breaking accomplishments of our first 150 years, and to look ahead at how our underlying land-grant philosophy can meet the challenges and opportunities of the twenty-first century.

For more than fifty years, international programs have been an essential part of our land-grant mission and a defining characteristic of Michigan State University. Originally founded to meet the needs of Michigan's citizens in 1855, MSU has transformed itself and evolved to meet new challenges throughout its history and continues to do so today. As our world has become "smaller" over the years, our mission has become larger, encompassing a broader responsibility, not only to the people of Michigan, but also to those of our nation and of our world. With global opportunities and issues affecting us in so many ways, the direction of our international engagement is crucial to building our collective future. Today, more than ever, we are called upon to address society's most complex and perplexing problems and to make a difference in people's lives.

MSU is internationally recognized for its commitment to study abroad programming and is a national leader in the field. With more than two hundred programs on all seven continents, nearly 2,500 students will participate in MSU study abroad this year.

Michigan State also offers a robust, globally engaged environment on campus. MSU hosts some 4,000 international students and scholars each year; nearly 1,200 faculty and staff members regularly participate in international scholarship, instruction, and work abroad; more than two dozen internationally oriented centers, institutes, departments, and offices are part of Michigan State; and approximately 2,000 alumni have served in the Peace Corps since it was created in 1961.

This book is a pictorial celebration of Michigan State's international activities and involvements. Some of the photographs date back more than a century, while others were taken as recently as last year. Internationally engaged faculty members provide the accompanying text to establish context for the photographs. The centerpiece of this book comes from a relatively recent tradition: the annual MSU Global Focus international photography competition. Sets of winning photographs from the first five years of the contest, grouped by world regions, depict scenes and events captured by the cameras of MSU students, faculty, staff, and alumni. These photographs, taken on study abroad programs, international project assignments, and personal travel experiences, form the aesthetic core of the book. By publishing these images and the recollections that go with them, we hope to share some of those experiences and how they've contributed to Michigan State's international dimension with a broader audience.

I have been fortunate to both witness and participate in MSU's advance to the vanguard as a national and global leader in international programming and engagement firsthand. And as the university's twentieth president, I look forward to continuing my participation in MSU's vital international efforts, traveling to other countries to represent the university, meeting and visiting with our international partners and stakeholders, and promoting the outstanding work of our faculty, staff, and students around the world.

Advancing Knowledge. Transforming Lives. That is how we sum up our land-grant mission today. And at its core, this means we make a difference in people's lives—not just those people who come to Michigan State, but all of the people whose lives we touch around the world. The photographs and text in this book tell an important part of that story, one that helps define who we are and one in which all of us who are part of Michigan State can take tremendous pride.

LOU ANNA K. SIMON
President, Michigan State University

This book blends past and present images from Michigan State University's heritage of international engagement. In presenting them, we recognize not only the breadth and depth of institutional commitment over many decades, but also our contemporary recommitment to expanding the scope of internationalization at MSU in teaching, research, and outreach.

As a portion of this photographic record reflects, MSU's international connections can be traced back to the latter part of the nineteenth century. However, the strongest evidence of an institutional-level commitment to international activity is found in MSU's post–World War II reconstruction efforts in Europe and Asia, and later in a wide array of development projects in other major world regions, especially in Africa and Latin America.

Leadership for an expansion of international engagement came from John Hannah, the university's twelfth president. He foresaw a globally interdependent future in the wake of World War II and an obligation for universities, particularly land-grant institutions, to be resources "not only for the state and nation, but for the world." Hannah's vision and drive led to the university's involvement in the creation of higher education institutions during the 1950s and early 1960s in places such as Brazil, Colombia, Japan, Nigeria, and Pakistan, and subsequently in more than two hundred major development, research, and technical assistance projects in dozens of countries.

In 1956 Hannah established the Office of International Programs, headed by a dean—the first such office among major universities in the United States. Later renamed the Office of International Studies and Programs (ISP), the office's primary job was administering the university's growing number of projects abroad. ISP's mission also included supporting expansion of international programs on campus. In the late 1950s and early 1960s ISP offices were established to support study abroad and visiting international students and scholars. The number of international students studying at MSU grew from a handful to hundreds and eventually to several thousand annually. Area studies centers were added during the 1960s and early 1970s for Africa, Asia, Latin America and the Caribbean, Europe and Russia, and Canada. Four of these centers have been recipients of U.S. Department of Education Title VI grants as National Resource Centers, and they all serve a broad array of clientele in business, K–12 education, government, and the private sector.

A number of the internationally focused thematic institutes and programs that are housed in the academic colleges came into existence during the 1970s, 1980s, and 1990s. Among these were the Center for Advanced Study of International Development (CASID), the Center for International Business Education and Research (CIBER), the Women and International Development Program (WID), and the Center for Language Education and Research (CLEAR)—all of which are either Title VI National Resource Centers or Language Resource Centers. Other successful thematic centers established from the 1960s onward include the Office of International Studies in Education, the International Communication Institute, the Institute of International Agriculture, the Institute of International Health, and the Institute for Global Engineering Education.

Through efforts of its faculty, academic units, and international centers and institutes, MSU is a top university recipient of contracts and grants from the United States Agency for International Development and has received major support for international projects from scores of other donor and granting agencies and foundations. Many of the historical as well as contemporary images of MSU's activity abroad come from faculty, students, and staff who have worked on these development projects.

In 1995, with active support and leadership from a relatively new MSU president, Peter McPherson, an institution-wide effort began to greatly expand the university's study abroad offerings and participation rate. Companion efforts were begun to expand international undergraduate and graduate student enrollments and to improve the integration of international students into the campus living and learning environments. A renewed institutional commitment to problem solving abroad led to, among other actions, the creation of the Office of International Development, with the charge to help form cross-college interdisciplinary teams for work abroad. And, most recently and significantly, broad-based institutional efforts have been underway to widely internationalize the on-campus curriculum and the university's outreach programs to the state and nation. A wide range of web-based resources have been developed to support portions of these instructional and outreach efforts. MSU is also leading a nationwide effort to expand the availability of instruction in less commonly taught languages, including innovative developments in technology.

As we reconfirm and update our institutional commitment to international engagement, we have a vision to guide both our aspirations and our actions. We believe that a university of international distinction and twenty-first-century influence is a local, national, and international resource for

knowledge creation and knowledge dissemination. Such a university promotes problem solving to address society's needs, both locally and globally. It advances diversity within the community by encouraging greater understanding of a multicultural and global society. All students, faculty, staff, and other university clientele should have broad opportunities to become globally aware, capable of collaborating with colleagues and clients at home and abroad, and able to operate effectively in a global environment.

A global university integrates internationalization across the missions of teaching, research, and outreach. We think it is essential to expand opportunity to all students, faculty, and staff to acquire foreign language competence, international understanding, and experience of the world abroad. We seek to integrate globally informed content throughout the curricula and to synthesize comparative and global perspectives into the research and projects of faculty. We extend the benefits of cross-cultural and comparative understanding through outreach programs to citizens, businesses, and public officials.

The photographic images in this book, spanning over a century, reflect the diversity of MSU's commitment to internationalization both on campus and through projects, study, and research abroad. With the advent of digital photography, more of our international involvements are being documented photographically, and more of these images are being made available through the Internet. Our continuing commitment to international activity will certainly entail expansion and diversification in the photographic record of our international involvements.

JOHN K. HUDZIK

Dean of International Studies and Programs

ACKNOWLEDGMENTS

Many people have supported this project, some with their ideas and vision, others with their referrals to sources of information and images, still others (those sources themselves) with their knowledge of MSU's international history and their documents and photographs. To these latter participants, let me express my appreciation for trusting me with your stories and your photographs.

I would like to thank the editorial board members for their time and energy in shaping this project and bringing it to fruition. They are Darcy Greene, Michael Lewis, Charlie Sharp, Michael Unsworth, and David Wiley. Additional guidance was provided by ISP Dean John K. Hudzik and Associate Deans Dawn Pysarchik and Jeffrey Riedinger.

Substantial components of the text were written by others, including the regional background sections from the directors of MSU's five area studies centers and the foreword and preface from MSU President Lou Anna K. Simon and John K. Hudzik, respectively. I very much appreciate these perspectives, which give the photographs and their captions additional depth.

Folks at MSU's University Archives and Historical Collections have been most helpful in aiding my search for older photographs and background information; many of the images we selected for inclusion come from that collection.

Many people must be commended for their patience with me during the lengthy development of this project. These include numerous colleagues who I have pestered relentlessly and members of my family who have supported the major demands on my time that the project has entailed.

I wish to acknowledge the generous contributions of Ralph Smuckler, former dean of International Studies and Programs, who read and commented on portions of the book and helped me in other ways to understand more about MSU's international history. His book, *A University Turns to the World: A Personal History of the Michigan State University International Story*, was a major resource for me and provided additional context for many of the images in this book.

Other publications of great value in this project were Paul H. Dressel's *College to University: The Hannah Years at Michigan State* and an internal ISP document compiled by Nancy E. Horn, *A Project History of Michigan State University's Participation in International Development 1951-1985*. Stacey Bieler and her *"Patriots" or "Traitors"? A History of American-Educated Chinese Students* provided helpful background on the Cosmopolitan Club.

Finally and most important, to the individuals both known and unknown who took the photographs featured in this book, I thank you for providing the core content of this volume. Your vision is a gift which we can now all appreciate.

"Global focus" is an apt term for the span of Michigan State University's international involvements, which include all of the academic colleges and thousands of members of the MSU community in any given year. MSU has a long, rich, and complex international history. Much of the university's national and international reputation and much of its self-image are rooted in international activities and involvements.

Global Focus—or more specifically MSU Global Focus—is also the name of the international photography competition sponsored annually by the MSU Office of International Studies and Programs (ISP) and the MSU Alumni Association. The first round of the competition was in fall 1999, and since then some 1,000 students, faculty, staff, and alumni have participated in the contest. The collection of nearly 180 winning photographs is on display throughout the MSU International Center. They have been published annually in the *MSU International*, the ISP news magazine, and they also are exhibited in our online MSU Global Focus gallery at *www.isp.msu.edu/photocontest*. Several other publications have featured individual winners or small sets. We are proud and excited to feature a sizeable selection of these photographs, arranged by world region, in this book. (See the appendix for a complete list of winners from 1999 through 2003.) In combining these images with a set of context-setting photographs representing MSU's tradition of international involvements, we hope to provide a unique view of MSU as a globally engaged university.

We have striven for balance in this book. We have grouped most of the photographs into four geographic regions, with introductory text from the directors of our related area studies centers addressing MSU's involvements related to those regions. We have attempted to select a roughly equivalent number of photo competition images for each section. These images were selected by the editorial committee with an eye on variety of content and location as well as aesthetic and thematic appeal.

We also undertook a major collection project to identify images related to past and current international initiatives and connections, ranging from technical assistance and institution building projects beginning in the 1950s

in Africa, Asia, and Latin America to current projects on six continents; from basic project work in agriculture, the environment, medicine, and science to activities related to education, communication, democratic institution building, and humanities; and including archival photographs dating as far back as the 1870s, as well as a broad sampling from the past six decades and numerous images from the present day. We also have included images of students on study abroad programs in every region, relying on a small set of such photographs to represent MSU's leadership and commitment to the study abroad enterprise. Photographs of some of the many multinational international projects and accomplishments that do not fit neatly into the regional divisions of this book are included in this introduction.

Given practical restrictions on the size of this book, the photo selection is intended to be representative, not comprehensive; the images we have selected only scratch the surface. These photographs and accompanying captions cannot pretend to summarize the depth and breadth of the projects they portray. Thus, numerous major projects are not featured, and a multitude of people and important contributions are unmentioned. Also, this is not a history book in any academic sense. We hope that the photographs draw you in as a result of their visual merits while piquing your curiosity about the accompanying text. Perhaps some of you will be stimulated to further investigation, including reading published accounts of MSU's history and visiting websites related to MSU's international activities. Some may be inspired to become involved in these enterprises in some way, perhaps through attending international activities on campus, or through supporting programs for international students and their families, or through contributing to study abroad scholarship funds, or through other sorts of action. There are tremendous opportunities for involvement. ▶

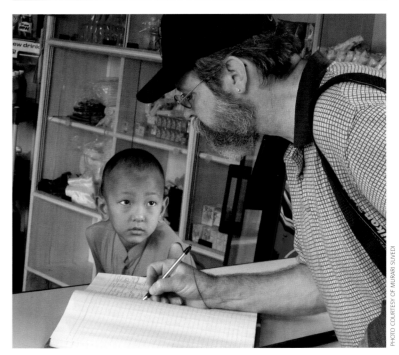

PHOTO COURTESY OF MURARI SUVEDI

In October 2003 Jay Rodman accompanied a group of Michigan secondary school teachers and MSU educators on a Fulbright-Hays Group Projects Abroad study tour to Nepal. While there, they visited a Buddhist monastery in Pokhara. The young lama saw them from the high window of his quarters and had his attendants bring him down to observe them at close range. Here he watches Rodman sign the guest book at the small store for visitors. Murari Suvedi, ISP assistant dean at the time and one of the leaders of the program, took this photograph.

T HE MSU GLOBAL FOCUS
international photography
competition rules stipulate that
submitted photographs must be
taken outside the United States.
But a book about MSU's inter-
national tradition must not
ignore international activities
taking place at the university and
elsewhere within the United
States, or the influence of inter-
national faculty, students,
scholars, and visitors on campus.

International students have
played a huge role in the univer-
sity's history and current place in
the world. From a handful in the
late 1900s, their numbers have
grown to over 3,000 in any given
year, and they typically represent
more than 125 nations. ▶

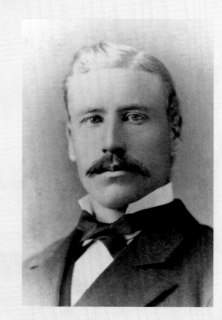

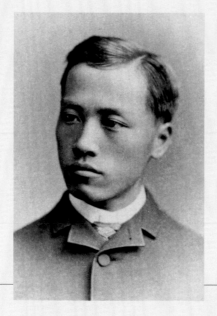

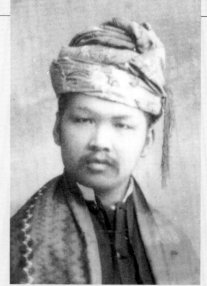

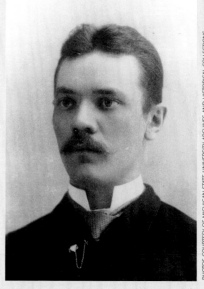

Four early international students at the State
Agricultural College (as MSU was then called) were
(*left to right*) Charles C. Georgeson of Denmark
(1878), Michitaro Tsuda of Japan (1884), Kolai S.
Thabue of Burma (1891), and Vadim A. Sobennikoff
of Russia (1897).

These two Cosmopolitan Club photographs are from the 1914 and 1926 editions of *The Wolverine*, the university's yearbook of that time period.

RIGHT: In 1914 the club had twenty-three student members. The president that year was Ming Sear Lowe of Kwongtung, China (*second row, fourth from left*).

BELOW: In 1926 there were thirty-eight "active members" from over a dozen countries, plus the United States. K. M. Liu of China (*front row, fourth from left*) was president at that time.

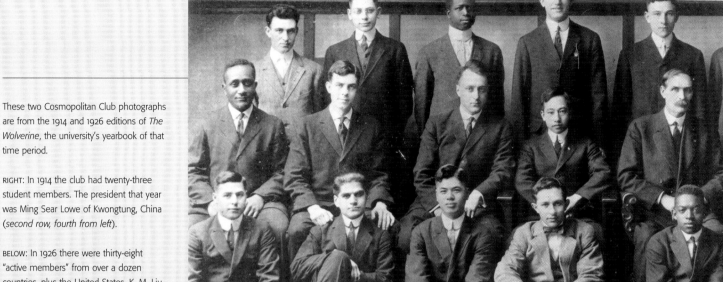

1914

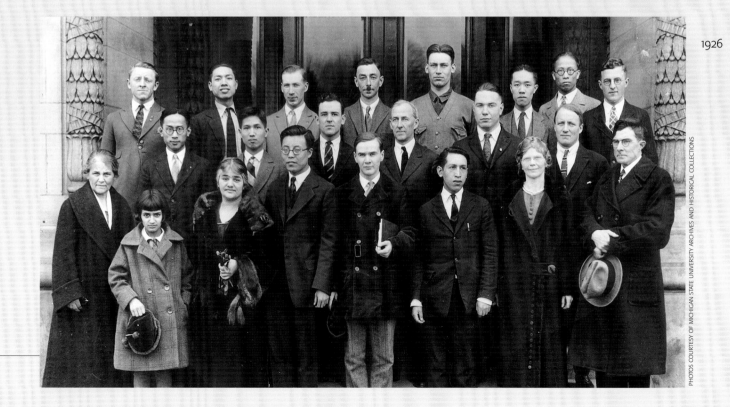

1926

Student organizations have helped international students feel more at home in an unfamiliar environment. In the early 1900s many international students belonged to the Cosmopolitan Club. An international organization founded in Italy as *Corda Fratres* (Brothers in Heart), it was introduced into the United States after the turn of the century. A chapter was founded at Michigan Agricultural College (as MSU was then called) in 1910 to provide a social setting for international and domestic students to become acquainted. Today MSU has dozens of international student organizations, most of which are related to particular countries or regions. ▶

One cannot overemphasize the importance of international faculty in the internationalization of MSU. While pursuing important academic work, they also bring their home cultures to the institution and to the broader community. And for decades MSU's international faculty have supplied content for a wide variety of on-campus activities, in addition to making themselves available to schools and community groups wishing to learn more about the world. In sharing their diverse cultures, they enrich the university and the surrounding community.

The original International Center, established in the 1940s, was "house number four" on Faculty Row. S. C. Lee and his wife lived upstairs, and the ground floor provided a place for the small numbers of international students to gather and get to know one another. The houses on Faculty Row were eventually razed. A large permanent structure, the Center for International Programs, was completed in 1964. It houses library facilities, a bookstore, a food court, and a snack shop, ▶

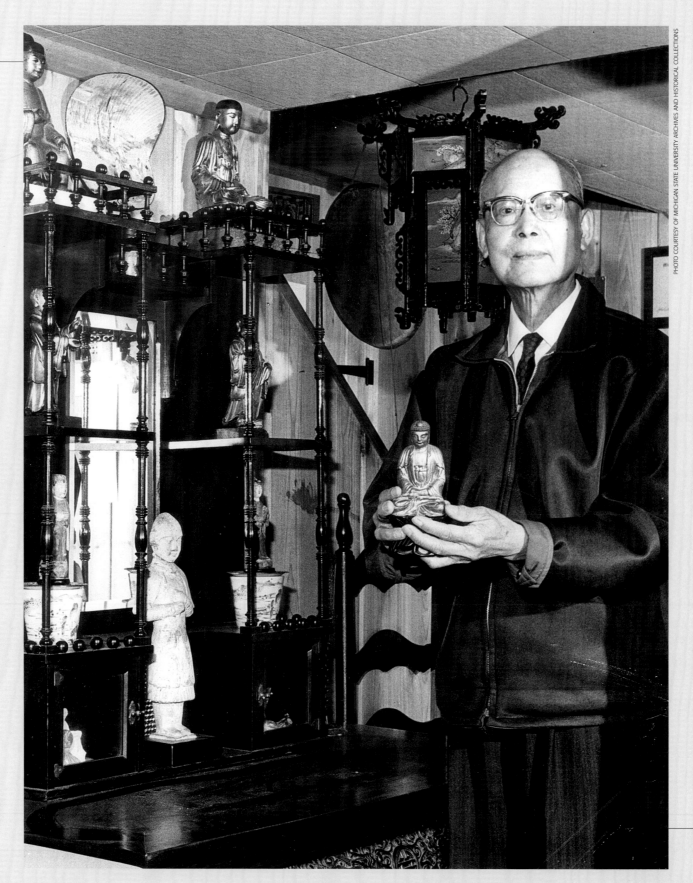

PHOTO COURTESY OF MICHIGAN STATE UNIVERSITY ARCHIVES AND HISTORICAL COLLECTIONS

In 1943 Michigan State College of Agriculture and Applied Science (as MSU was then called) hired Professor Shao Chang Lee to help create a new Institute of Foreign Studies. Born in China in 1891, Lee had received his early education there before coming to the United States and earning degrees at Yale and Columbia. Prior to coming to MSU, he had a long and distinguished career as a professor and administrator at the University of Hawai'i. MSU's new institute offered international courses and sponsored international lectures and other activities. Lee continued to head up the Institute (and later Department) of Foreign Studies until his retirement in 1960.

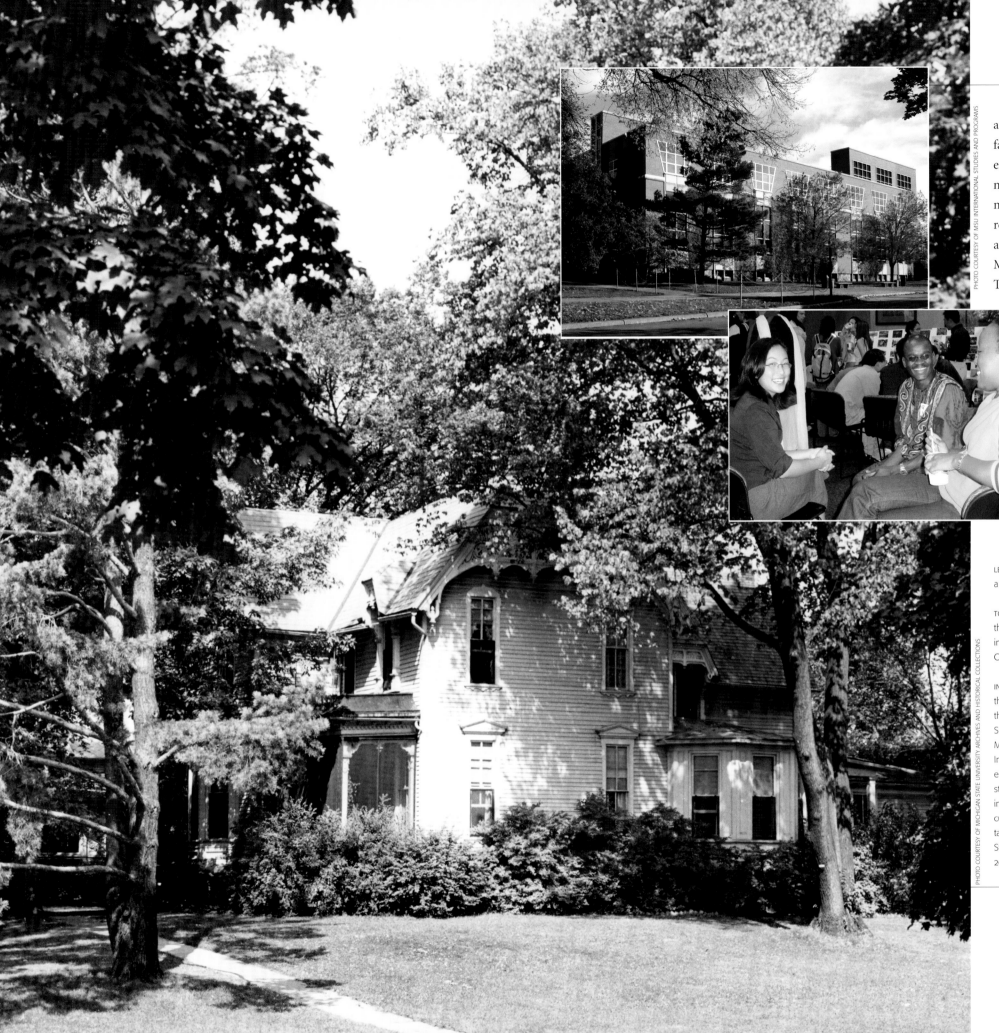

PHOTO COURTESY OF MSU INTERNATIONAL STUDIES AND PROGRAMS

PHOTO COURTESY OF RAVI AMMIGAN

PHOTO COURTESY OF MICHIGAN STATE UNIVERSITY ARCHIVES AND HISTORICAL COLLECTIONS

as well as the offices and support facilities of ISP. In 2003 an expanded academic wing was named the Delia Koo International Academic Center in recognition of Dr. Koo's financial and substantive contributions to MSU's international mission. Today's International Center is a focal point for international education on campus, as well as a place where MSU's international community congregates informally, much as they did at S. C. Lee's home. ▶

LEFT: The original International Center was a house on Faculty Row.

TOP: Today's International Center was built in the early 1960s and was recently expanded to include the Delia Koo International Academic Center.

INSET: Students from many countries, including the United States, gather along with staff from the Office for International Students and Scholars and other interested members of the MSU community on Friday afternoons for International Coffee Hour. The tradition was established in 2002 in an effort to build a stronger sense of community among MSU's international students and to foster intercultural understanding. This photograph was taken by Ravi Ammigan, Office for International Students and Scholars (OISS), in September 2003.

Soon after the original International Center was created, students formed the International Club of Michigan State College. An annual International Festival, featuring performances and displays, became a tradition of the club. Today's equivalent of the International Festival is the annual Global Festival, organized every year by the Community Volunteers for International Programs. The organization was founded in 1959, mainly as a coat-lending center, supplying winter coats and other items to the families of international students. Today the organization supports international students and their families in many ways, including funding scholarships for spouses of international students. The Global Festival attracts thousands of attendees every year from campus and the Lansing area for a November Sunday afternoon of international exhibits, performances, food, and activities. ▶

BLACK-AND-WHITE: These four photographs were taken at International Festivals in the 1950s.

COLOR: These Global Festival photographs from the early 2000s show a student from South Korea at his organization's booth and Greek students performing a traditional dance.

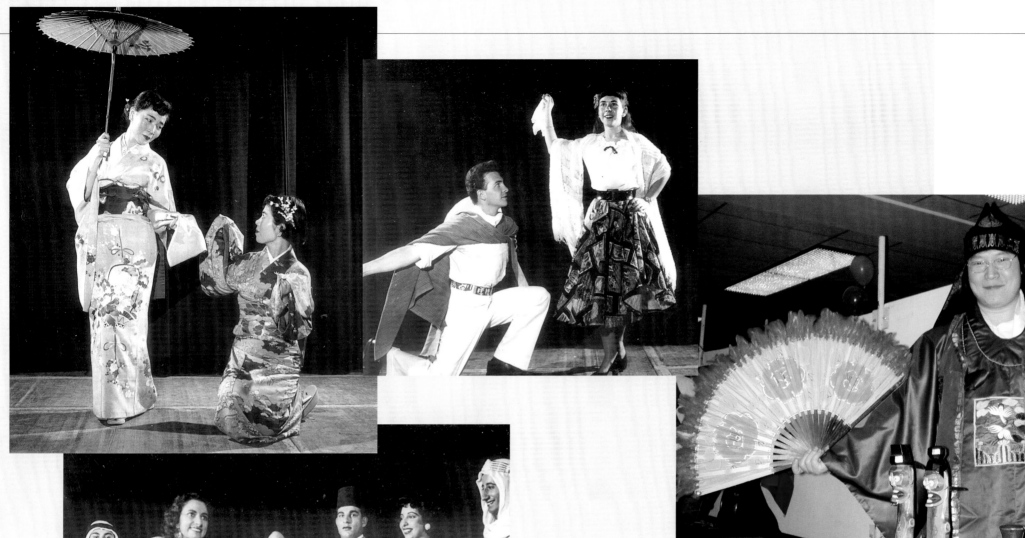

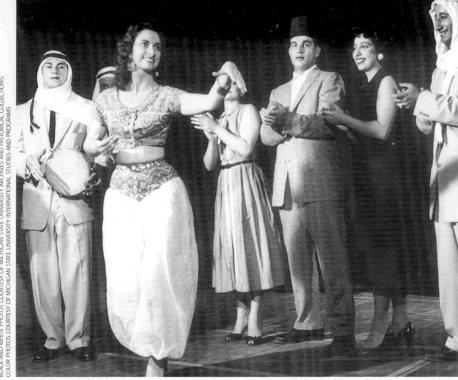

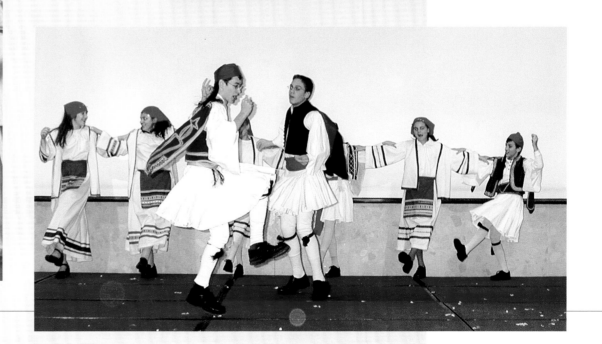

Some international projects have involved bringing groups of international scholars to MSU, rather than sending MSU students and faculty abroad. For example, toward the end of World War II, President John Hannah brought internationally renowned scholars to the institution as he sought to anticipate postwar needs in international education. Projects such as these enrich our campus directly while meeting the needs of international constituencies. ▶

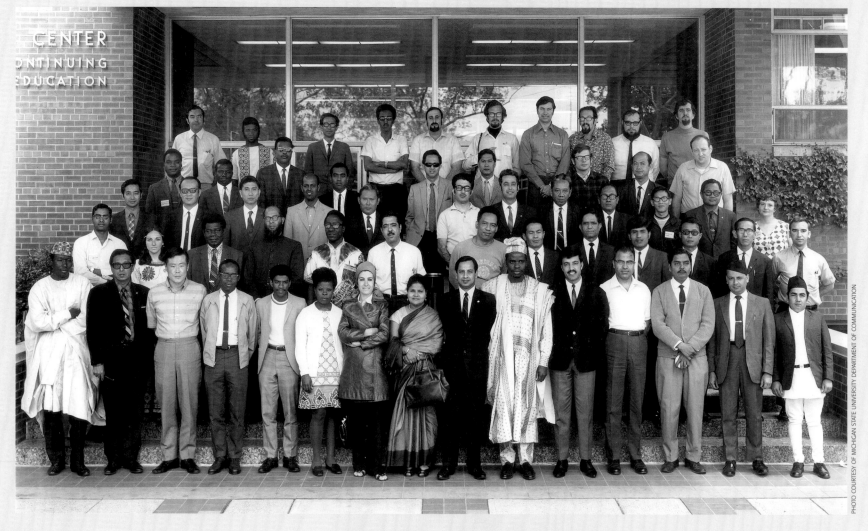

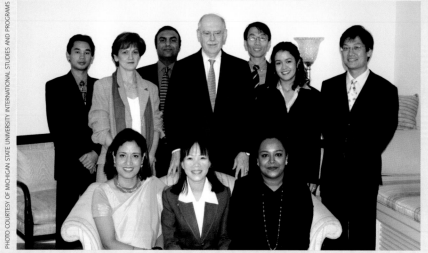

ABOVE: Between 1958 and 1978 the College of Communication Arts and Sciences received funding from the International Cooperation Agency and USAID to conduct week-long seminars for international scholars who had been studying in the United States. These seminars were designed to enhance the participants' effectiveness in using their newly acquired knowledge and skills to initiate positive change upon returning to their home countries. This photograph, from a 1970 seminar, shows participants from many nations along with seminar faculty.

LEFT: In 2002 MSU was selected to join twelve other major U.S. universities for participation in the prestigious Hubert H. Humphrey Fellowship Program. This non-degree Fulbright exchange program brings midcareer professionals in leadership positions from around the world to select U.S. campuses. Once in residence, they participate in rigorous and tailored academic and professional development activities over the course of a ten-month period. MSU is one of two host universities working with participants in the area of economic development. In October 2003 this 2003–4 cohort met with President McPherson at a reception in their honor.

Perhaps the most important international project that the College of Education has participated in is the Third International Math and Science Study (TIMSS). William Schmidt, Counseling, Educational Psychology, and Special Education, has coordinated U.S. participation in this influential cross-national study of primary and secondary math and science education in about sixty countries. According to Jack Schwille, assistant dean for international education in the College of Education, TIMSS "is one of the largest and most complex empirical studies in behavioral and social sciences ever attempted." The results of this study have major implications for education in the United States and elsewhere. President Bill Clinton praised the study when he briefed the press on the fourth grade TIMSS results in a Rose Garden ceremony in 1997. In this Oval Office photograph taken immediately after the ceremony, Clinton (*fifth from left*) stands with Schmidt (*fourth from left*) and Secretary of Education Richard Riley (*second from left*), Bruce Alberts, president of the National Academy of Sciences (*far left*), and representatives of the National Center of Educational Statistics.

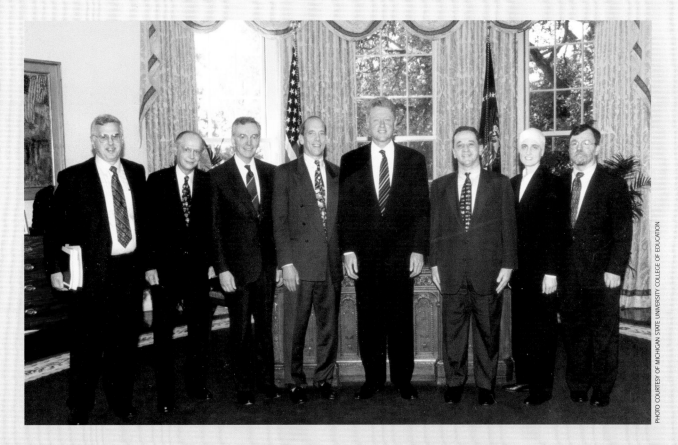

PHOTO COURTESY OF MICHIGAN STATE UNIVERSITY COLLEGE OF EDUCATION

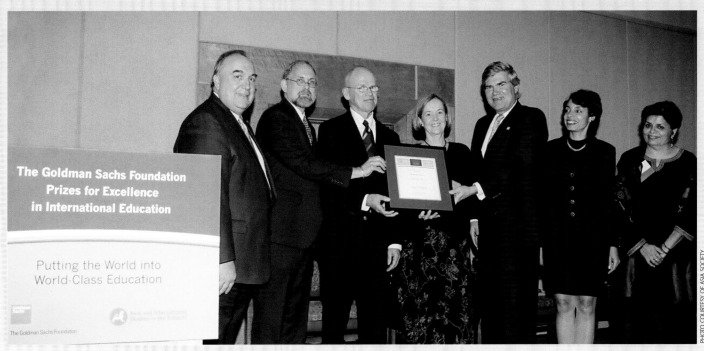

The Goldman Sachs Foundation Prizes for Excellence in International Education

Putting the World into World-Class Education

The Goldman Sachs Foundation

PHOTO COURTESY OF ASIA SOCIETY

Accepting the 2004 Goldman Sachs Foundation Prize on behalf of MSU were John Metzler, African Studies Center; Jack Scwhille, College of Education; Sally McClintock, LATTICE; and David Porteous, chair of the Board of Trustees (*second, third, fourth, and fifth from left, respectively*). They were joined by former Michigan Governor John Engler (*left*), Asia Society President Vishaka Desai, and Goldman Sachs Foundation President Stephanie Bell-Rose at the ceremony in Washington, D.C.

M SU researchers often receive national recognition for their international work. Whether in the national media or in the professional journals, they have an impact on their fields of study as well as on the lives of people around the world. Sometimes their achievements even take them to the White House.

MSU has been the recipient of many awards over the years for the strength of its international involvement. In November 2004 MSU received national recognition as the winner of the Goldman Sachs Foundation Prize for Excellence in International Education in the higher education category. This was the second year of this prize, which is awarded to one institution annually for its commitment to an international emphasis in teacher preparation or to international outreach efforts for educators. ▶

MSU faculty work with international colleagues on major projects here in the United States as well as abroad. There are many examples of multinational research groups on campus, as well as examples of international faculty collaborating with colleagues in their countries of origin. MSU faculty also participate with multinational teams of researchers at research facilities far from our campus, and facilities on our campus are utilized by international teams of researchers. ▶

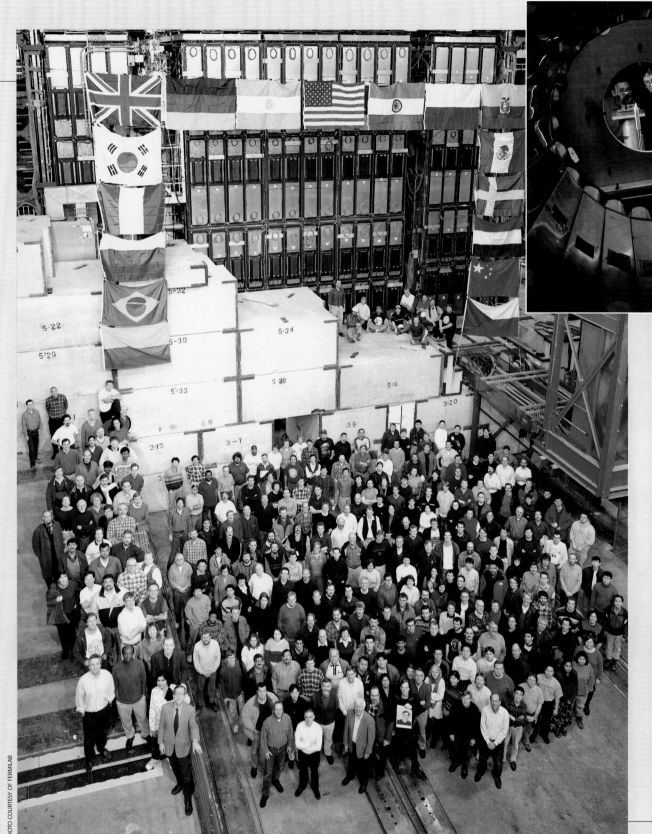

PHOTO COURTESY OF FERMILAB

PHOTO COURTESY OF NATIONAL SUPERCONDUCTING CYCLOTRON LABORATORY

ABOVE: MSU is the home of the National Super-conducting Cyclotron Laboratory (NSCL), the leading rare isotope research facility in the United States. In addition to providing facilities for research by MSU scientists, NSCL has attracted more than 600 scientists from across the United States and abroad to conduct research related to the properties of atomic nuclei and the origins of the elements in the cosmos. In late 2003 an important set of experiments took place at NSCL involving a Japan–U.S. collaboration funded jointly by the Japan Society for the Promotion of Science and the U.S. National Science Foundation. It was the first use of a liquid hydrogen target at NSCL, which was supplied by the Japanese research organization RIKEN. This photo-graph shows equipment used in the experiments.

LEFT: MSU scientists in the High Energy Physics group in the Department of Physics and Astronomy are involved in numerous collaborative projects involving scientists from many nations. MSU was one of the founding institutions of the DZero Experiment, designed to study the behavior of subatomic particles at the Tevatron, a high-energy accelerator at Fermilab in Illinois. Joining a group of some 700 scientists from 70 institutions, about half of which are from outside the United States, they "search for subatomic clues that reveal the character of the building blocks of the universe." This detector was one of two that discovered the top quark in 1995. The MSU group built the critical trigger part of this detector. This photograph shows a large group of these researchers, along with flags from many of their countries of origin, at the detector facility.

IN THE FOLLOWING FOUR SECTIONS, you will find photographs related to various regions of the world. To a certain extent, our divisions are consistent with the "division of labor" of our area studies centers. For this reason, we have asked our area studies center directors to write brief overviews of MSU's activities related to their respective geographic areas of concern. David Wiley, director of the African Studies Center, has written the text for the Africa and Middle East section; Michael Lewis, director of the Asian Studies Center has done likewise for the Asia and Oceania section; Scott Whiteford, director of the Center for Latin American and Caribbean Studies, and Phil Handrick, acting director of the Canadian Studies Centre, have collaborated on writing about the Americas; and Norman Graham, director of the Center for European and Russian Studies, discusses MSU's involvement in Europe and the countries of the former Soviet Union.

Photographs from the MSU Global Focus international photography competitions are featured in each of these sections, one to a page, with minimal accompanying text; for the most part, these images speak for themselves, although a bit of context information, supplied by the photographers, is included with the images. Photographs representing MSU's international history and current international involvements, generally presented in groups, are intended to emphasize that the winning photographs are, in a sense, a product of MSU's many decades of international evolution.

A GOOD PHOTOGRAPH goes beyond preserving a scene, freezing a moment in time; it captures the essence of that scene in a way that helps us understand our world in a new way. We hope that this collection of photographs and accompanying texts serves as much more than a documentation of international moments, that it manages to capture the essence of MSU's international engagement—its "global focus"—at the mature age of 150 years. ■

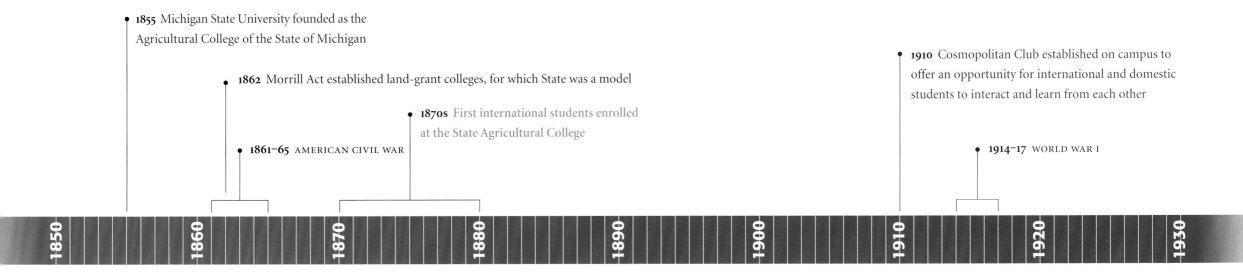

1855 Michigan State University founded as the
Agricultural College of the State of Michigan

1910 Cosmopolitan Club established on campus to
offer an opportunity for international and domestic
students to interact and learn from each other

1862 Morrill Act established land-grant colleges, for which State was a model

1870s First international students enrolled
at the State Agricultural College

1861–65 AMERICAN CIVIL WAR

1914–17 WORLD WAR I

1850 1860 1870 1880 1890 1900 1910 1920 1930

This timeline presents a list of events related to MSU's history of international involvements set against a backdrop of other major MSU, national, and international events. In the same way that the photographs in this book are representative, not comprehensive, this list is not all-inclusive. Hundreds of international research, teaching, and outreach activities have taken place during the past half century, and the current total of MSU faculty and staff who are regularly involved in international activities exceeds 1,200. For more comprehensive information about MSU's international involvements, please consult the sources listed here, the sources listed in the bibliographies of these sources, and various MSU offices with records of these projects and activities.

Much of the above information is taken from Paul Dressel's *College to*

University and *A University Turns to the World* by Ralph Smuckler. *A Project History of Michigan State University's Participation in International Development 1951-1985*, compiled by a Nancy E. Horn, had much helpful information about grant-supported international projects. Other sources of information include a number of individuals who have been involved in projects, materials housed in University Archives and Historical Collection, and a variety of websites and publications. In some cases of project work, the year may be when a grant was received, rather than when work began on the ground. While we have striven for accuracy in this timeline, we have sometimes been presented with vague or conflicting information, and have chosen to include entries that might not be completely accurate in all details rather than to exclude them for lack of conclusive information.

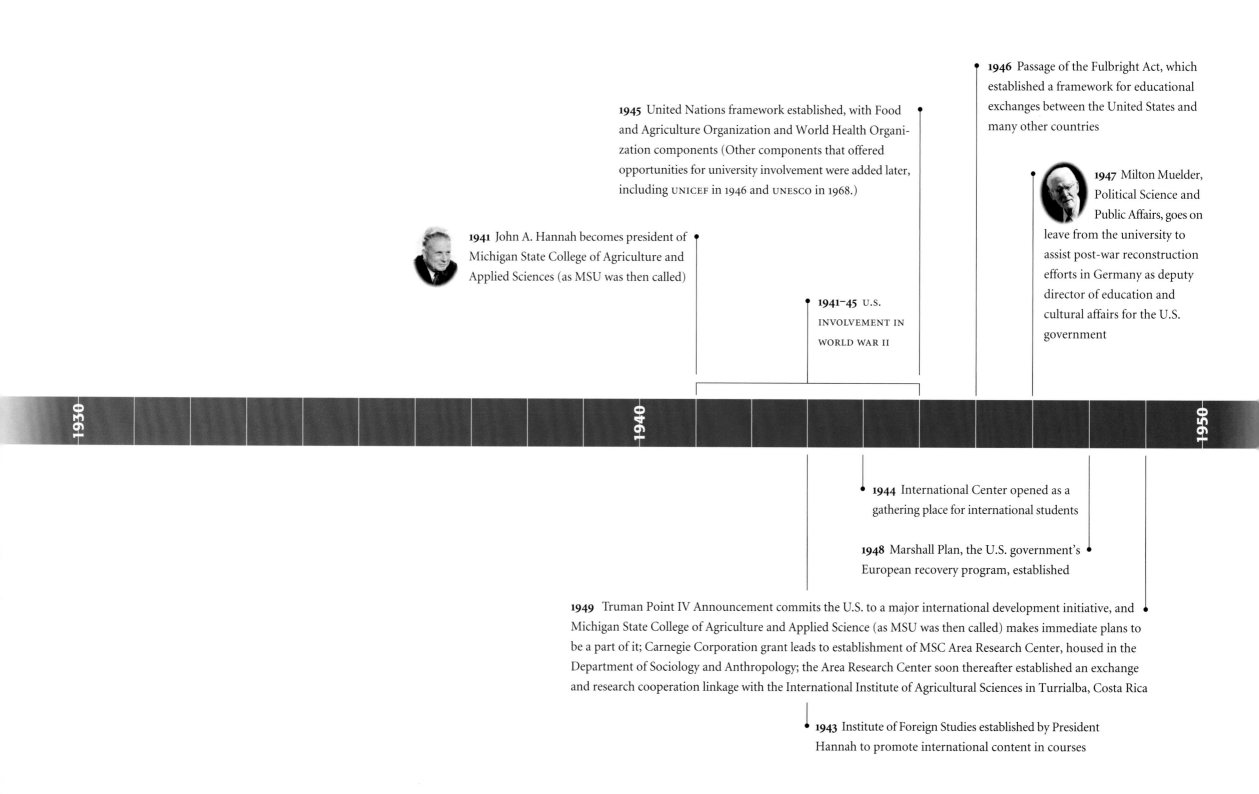

1946 Passage of the Fulbright Act, which established a framework for educational exchanges between the United States and many other countries

1945 United Nations framework established, with Food and Agriculture Organization and World Health Organization components (Other components that offered opportunities for university involvement were added later, including UNICEF in 1946 and UNESCO in 1968.)

1947 Milton Muelder, Political Science and Public Affairs, goes on leave from the university to assist post-war reconstruction efforts in Germany as deputy director of education and cultural affairs for the U.S. government

1941 John A. Hannah becomes president of Michigan State College of Agriculture and Applied Sciences (as MSU was then called)

1941–45 U.S. INVOLVEMENT IN WORLD WAR II

1930 1940 1950

1944 International Center opened as a gathering place for international students

1948 Marshall Plan, the U.S. government's European recovery program, established

1949 Truman Point IV Announcement commits the U.S. to a major international development initiative, and Michigan State College of Agriculture and Applied Science (as MSU was then called) makes immediate plans to be a part of it; Carnegie Corporation grant leads to establishment of MSC Area Research Center, housed in the Department of Sociology and Anthropology; the Area Research Center soon thereafter established an exchange and research cooperation linkage with the International Institute of Agricultural Sciences in Turrialba, Costa Rica

1943 Institute of Foreign Studies established by President Hannah to promote international content in courses

Late 1950s Foreign Student Advisor's Office (later renamed Office for International Students and Scholars) established in Office of International Programs

1958 Passage of Title VI of the National Defense Education Act enabled increased federal funding for a variety of international activities

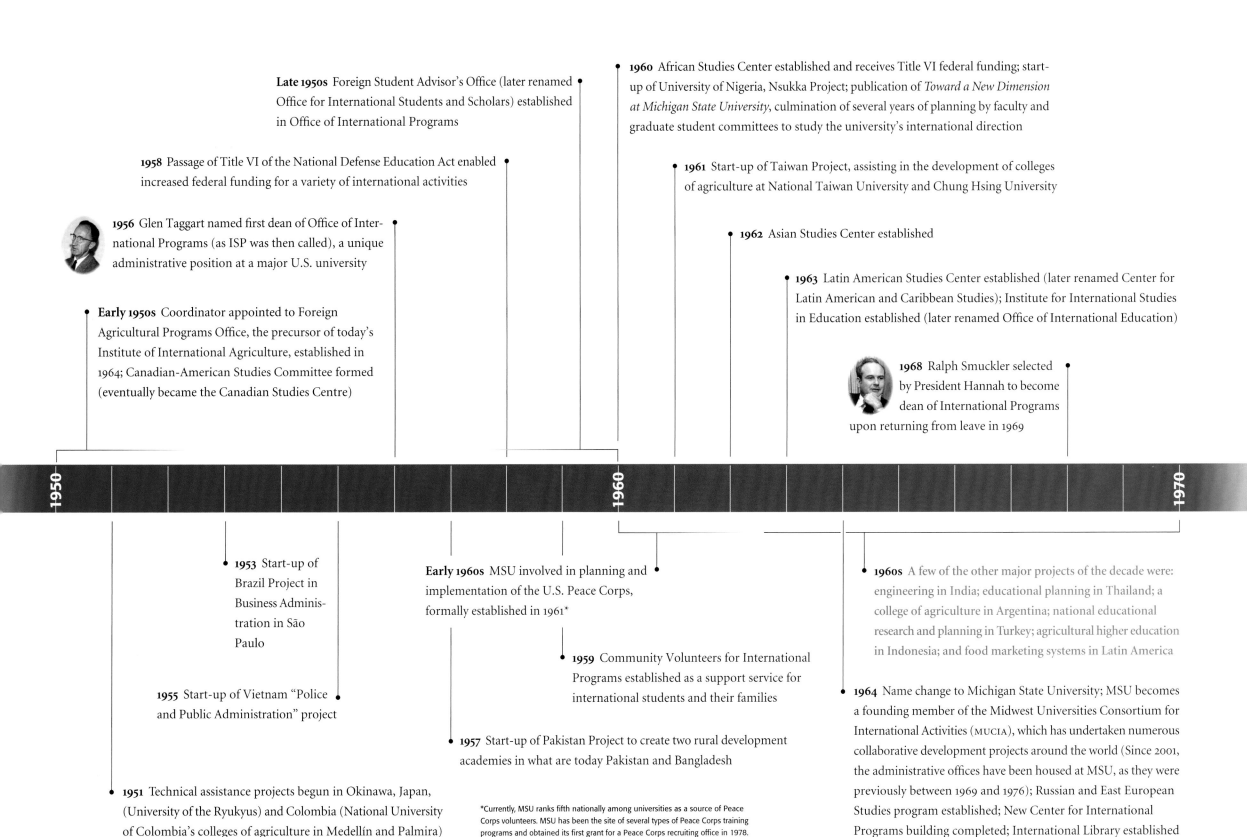

1956 Glen Taggart named first dean of Office of International Programs (as ISP was then called), a unique administrative position at a major U.S. university

Early 1950s Coordinator appointed to Foreign Agricultural Programs Office, the precursor of today's Institute of International Agriculture, established in 1964; Canadian-American Studies Committee formed (eventually became the Canadian Studies Centre)

1960 African Studies Center established and receives Title VI federal funding; start-up of University of Nigeria, Nsukka Project; publication of *Toward a New Dimension at Michigan State University*, culmination of several years of planning by faculty and graduate student committees to study the university's international direction

1961 Start-up of Taiwan Project, assisting in the development of colleges of agriculture at National Taiwan University and Chung Hsing University

1962 Asian Studies Center established

1963 Latin American Studies Center established (later renamed Center for Latin American and Caribbean Studies); Institute for International Studies in Education established (later renamed Office of International Education)

1968 Ralph Smuckler selected by President Hannah to become dean of International Programs upon returning from leave in 1969

1950 | **1960** | **1970**

1953 Start-up of Brazil Project in Business Administration in São Paulo

1955 Start-up of Vietnam "Police and Public Administration" project

1951 Technical assistance projects begun in Okinawa, Japan, (University of the Ryukyus) and Colombia (National University of Colombia's colleges of agriculture in Medellín and Palmira)

Early 1960s MSU involved in planning and implementation of the U.S. Peace Corps, formally established in 1961*

1959 Community Volunteers for International Programs established as a support service for international students and their families

1957 Start-up of Pakistan Project to create two rural development academies in what are today Pakistan and Bangladesh

*Currently, MSU ranks fifth nationally among universities as a source of Peace Corps volunteers. MSU has been the site of several types of Peace Corps training programs and obtained its first grant for a Peace Corps recruiting office in 1978.

1960s A few of the other major projects of the decade were: engineering in India; educational planning in Thailand; a college of agriculture in Argentina; national educational research and planning in Turkey; agricultural higher education in Indonesia; and food marketing systems in Latin America

1964 Name change to Michigan State University; MSU becomes a founding member of the Midwest Universities Consortium for International Activities (MUCIA), which has undertaken numerous collaborative development projects around the world (Since 2001, the administrative offices have been housed at MSU, as they were previously between 1969 and 1976); Russian and East European Studies program established; New Center for International Programs building completed; International Library established

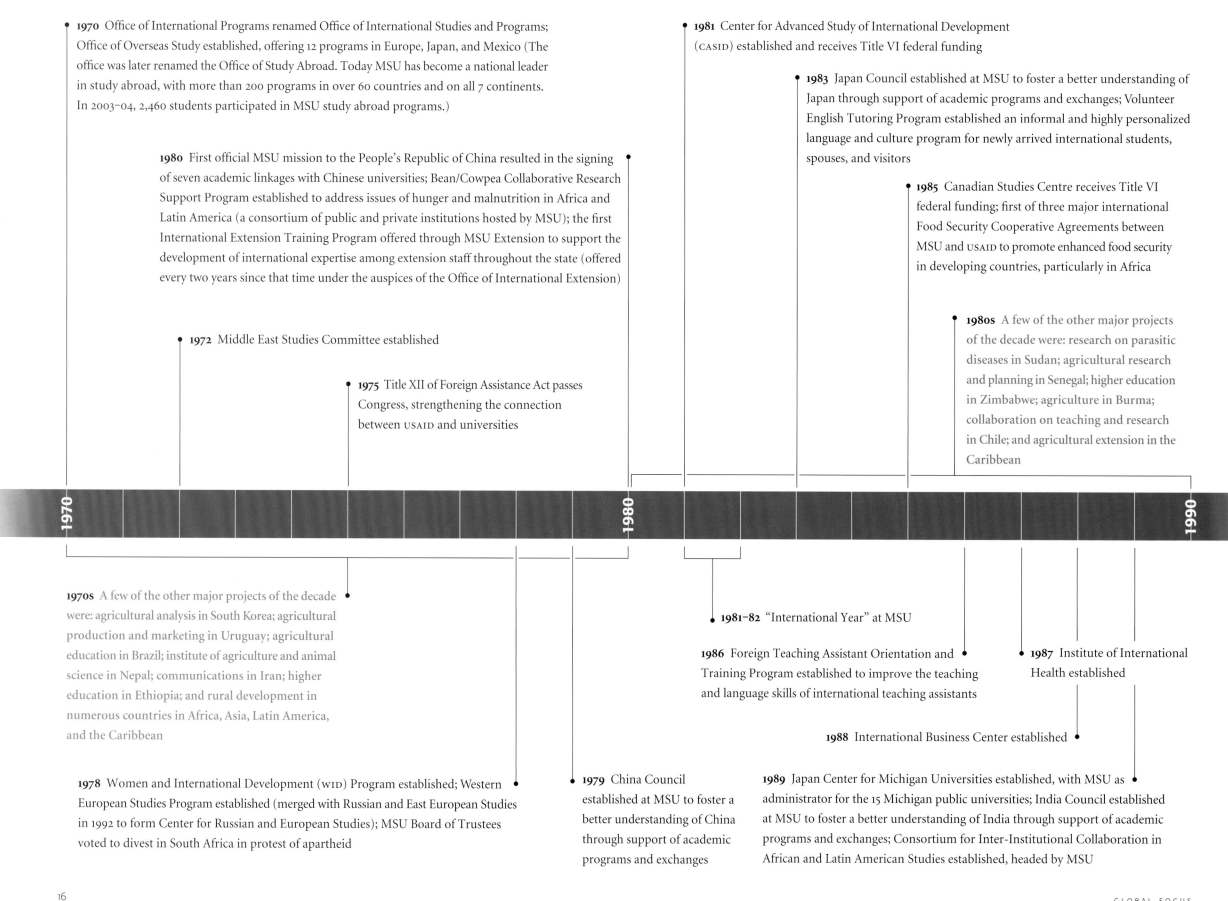

1970 Office of International Programs renamed Office of International Studies and Programs; Office of Overseas Study established, offering 12 programs in Europe, Japan, and Mexico (The office was later renamed the Office of Study Abroad. Today MSU has become a national leader in study abroad, with more than 200 programs in over 60 countries and on all 7 continents. In 2003–04, 2,460 students participated in MSU study abroad programs.)

1980 First official MSU mission to the People's Republic of China resulted in the signing of seven academic linkages with Chinese universities; Bean/Cowpea Collaborative Research Support Program established to address issues of hunger and malnutrition in Africa and Latin America (a consortium of public and private institutions hosted by MSU); the first International Extension Training Program offered through MSU Extension to support the development of international expertise among extension staff throughout the state (offered every two years since that time under the auspices of the Office of International Extension)

1972 Middle East Studies Committee established

1975 Title XII of Foreign Assistance Act passes Congress, strengthening the connection between USAID and universities

1981 Center for Advanced Study of International Development (CASID) established and receives Title VI federal funding

1983 Japan Council established at MSU to foster a better understanding of Japan through support of academic programs and exchanges; Volunteer English Tutoring Program established an informal and highly personalized language and culture program for newly arrived international students, spouses, and visitors

1985 Canadian Studies Centre receives Title VI federal funding; first of three major international Food Security Cooperative Agreements between MSU and USAID to promote enhanced food security in developing countries, particularly in Africa

1980s A few of the other major projects of the decade were: research on parasitic diseases in Sudan; agricultural research and planning in Senegal; higher education in Zimbabwe; agriculture in Burma; collaboration on teaching and research in Chile; and agricultural extension in the Caribbean

1970 | **1980** | **1990**

1970s A few of the other major projects of the decade were: agricultural analysis in South Korea; agricultural production and marketing in Uruguay; agricultural education in Brazil; institute of agriculture and animal science in Nepal; communications in Iran; higher education in Ethiopia; and rural development in numerous countries in Africa, Asia, Latin America, and the Caribbean

1978 Women and International Development (WID) Program established; Western European Studies Program established (merged with Russian and East European Studies in 1992 to form Center for Russian and European Studies); MSU Board of Trustees voted to divest in South Africa in protest of apartheid

1981–82 "International Year" at MSU

1986 Foreign Teaching Assistant Orientation and Training Program established to improve the teaching and language skills of international teaching assistants

1987 Institute of International Health established

1988 International Business Center established

1979 China Council established at MSU to foster a better understanding of China through support of academic programs and exchanges

1989 Japan Center for Michigan Universities established, with MSU as administrator for the 15 Michigan public universities; India Council established at MSU to foster a better understanding of India through support of academic programs and exchanges; Consortium for Inter-Institutional Collaboration in African and Latin American Studies established, headed by MSU

1990 Center for International Business Education and Research established and receives Title VI federal funding; Internationalizing Student Life created to promote cross-cultural competence among MSU students—the first office of its kind at a U.S. university

1991 Gill-Chin Lim appointed dean of Office of International Studies and Programs; Center for Latin American and Caribbean Studies receives Title VI federal funding; Agricultural Biotechnology Support Project established at MSU through a USAID cooperative agreement (to foster the application of environmentally compatible biotechnology to the solution of food security issues in developing countries); Visiting International Professional Program established to provide short- and long-term training opportunities at MSU for professionals from other countries

1992 Korea Council established at MSU to foster a better understanding of Korea through support of academic programs and exchanges

1994 WID receives Title VI federal funding as a partner with CASID

2000 Office of International Development established to assist MSU faculty and graduate students interested in implementing collaborative international research and development projects; Asian Studies Center receives Title VI federal funding; MATRIX–The Center for Humane Arts, Letters, and Social Sciences Online becomes involved in the first of several international projects to enhance the use of Internet technology in developing countries (These projects, most of which are in partnership with the African Studies Center, have included The Internet and Democratic Women's Organizing project in West Africa, the South African National Cultural Heritage project, and the African On-Line Digital Library project.)

2002 MSU selected as a host institution for the Hubert H. Humphrey Fellowship Program; MSU is one of only two universities hosting in the area of economic development

2004 MSU receives prestigious Goldman Sachs Foundation Prize for Excellence in International Education in the higher education category

2006 50th Anniversary of Office of International Studies and Programs

1990 · 2000 · 2010

1995 John Hudzik appointed acting dean of Office of International Studies and Programs, becomes dean in 1998; LATTICE (Linking All Types of Teachers to International Cross-cultural Education) formed as an MSU outreach project designed to help internationalize K–12 curriculum

1996 40th Anniversary of Office of International Studies and Programs; Center for Language Education and Research established and receives Title VI federal funding

1990s A few of the other major projects of the decade were: Afrobarometer (political research) in multiple African countries; social forestry education in Thailand; Third International Math and Science Study in many countries; research and analysis of NAFTA's effects on Mexican farmers; Guinea Small Grants Staff Development and School Improvement Program; and democracy training programs in Russia, Hungary, and Romania

2000s A few of the new major projects of this decade are: Partnership for Food Industry Development (PFID)–Fruits and Vegetables with work in Guatemala, Kenya, and South Africa; Partnership to Cut Hunger and Poverty in Africa; Partnership for Enhancing Agriculture in Rwanda through Linkages (PEARL); Linking Schools to Community Development in Vietnam; Faculty of Education Reform (FOER) Project in Egypt; partnership with other practitioners on major grants in the areas of women and international development, environmental policy and institutional strengthening, and integrated water and coastal resource management

There was a synergy in Nigeria's achieving independence from colonial rule in 1960—alongside sixteen other African nations—and the founding of the MSU African Studies Center in that same year. The story of MSU's focus on Africa actually began in the early 1950s, with a governor of the Eastern Province of the British Colony Nigeria, Nnamdi Azikiwe, who was to become the first civilian president of Nigeria in 1963. "Zik," as he affectionately was called by hosts of Nigerians, had a vision of a "people's university" for Nigeria to address the country's pressing development needs and to be modeled on the U.S. land-grant university. In the early 1950s he traveled to New York to request support from the Rockefeller, Ford, and other foundations for the first "American" university in Africa, but they refused. Zik told the story of being dejected at their rejection of his requests. Walking from the Upper West Side in Manhattan toward the downtown, he saw a skyscraper with "cobs of maize" carved in the limestone frieze. "I knew in an instant," he recalled, "that if you can build a skyscraper in New York with maize, you can build a university with palm oil in Nigeria."

Several years later Azikiwe returned to New York with a bank certificate for almost $50 million (in 2004 dollars) earned from a tax on palm oil production in Eastern Nigeria, and he again asked the foundations for assistance. This time, the foundations referred him to President John Hannah and MSU as a U.S. university partner and to the United States Agency for International Development as a source of funds. Hannah and a number of MSU faculty quickly accepted Zik's invitation. Founded in 1960 and staffed with thirteen faculty each from Nigeria and MSU, the University of Nigeria flourished until MSU left the country during the Nigerian/Biafran civil war. By 1967 the institution had thirty faculty from MSU and four hundred from Nigeria, and its first graduates earned the best civil service examination scores in the country.

George and Nancy Axinn, Glenn Johnson, Carl Eicher, Carl Liedholm, John Henderson, Lewis Zerby, Glenn Taggart, John Hanson, Richard Lewis, Ed Carlin, Jack Bain, Mel Buschman, and other MSU faculty and families too numerous to mention contributed more than two hundred person-years of effort to the University of Nigeria. From that experience, this faculty gained knowledge and affection for the Nigerian people, and they returned to bring an African focus to teaching, research, and service at MSU.

Now, forty-five years later, more than 150 MSU faculty have experience in Sub-Saharan and North Africa, and others have taught about the Middle East in the humanities and social sciences. The African Studies Center, a matrix unit serving faculty and students from fifty-nine MSU departments, is one of the leading and most comprehensive of such centers in the United States. In 1960 MSU was designated as a U.S. National Resource Center for African Studies by the U.S. Department of Education under Title VI of the Higher Education Act, and today it is one of nine such centers nationwide. The Middle East Committee, organized in 1972, unites faculty teaching about and researching that region.

One of MSU's major contributions to Africa over the years has been through the thousands of African students who have completed MSU B.A., M.A., and Ph.D. degrees at the university. MSU graduates have become vice presidents, legislators, ministers, permanent secretaries, vice chancellors, and directors of departments and institutes in government, higher education, and the private sector across Africa.

Since the early 1980s, MSU graduate students have produced more Ph.D. dissertations on Africa than students at any other North American university. To complete this research, MSU graduate students regularly compete successfully for awards from the Fulbright program, National Endowment for the Humanities, Social Science Research Council, National Science Foundation, and private foundations. MSU graduate students from the United States are supported by Title VI Fellowships for African language and area studies training.

These awards reflect the research engagement and graduate student mentoring of the faculty in the social sciences, economics, and agricultural economics, education, and in health and medicine. In addition, MSU has a strong Africanist humanities faculty with programs in history, literature, music, and the arts; leading U.S. faculties of African agriculture and veterinary science; and a unique faculty in African communications and journalism.

Another source of distinction has been MSU students' knowledge of African languages. With five African linguists at MSU, thirty African languages are offered on demand, from Acholi to Yoruba, Fulfulde to Xhosa, and including Hausa, Arabic, and Swahili. MSU's African Language Program is one of the leading such programs in the nation in improving African language instruction and creating a model for offering languages needed by scholars to conduct research in Africa.

MSU's faculty maintain linkages with many African universities, especially in Ethiopia, Malawi, Mali, Rwanda, Senegal, South Africa, and Zimbabwe. Recent faculty research and service activities have occurred in many other countries, as well: Botswana, Burkina Faso, Burundi, Cameroon, Côte d'Ivoire, Egypt, Eritrea, Gambia, Ghana, Guinea, Kenya, Lesotho, Liberia, Mauritania, Morocco, Mozambique, Namibia, Niger, Nigeria, Sierra Leone, Sudan, Tanzania, Uganda, and Zambia. Across these countries, MSU offers 10 percent of all U.S. study abroad programs, more than any other U.S. university, and the university hosts the headquarters of the National Consortium for Study in Africa, which brings together U.S. universities seeking to increase high quality opportunities for American students in Africa.

Many MSU faculty have focused on addressing the development needs of the African continent. MSU faculty involvement in agriculture in Africa is probably the largest of any U.S. institution, including dozens of projects on food security, drought coping, food markets, women in development, new crop varieties, and training African faculty. The Veterinary and Animal Science faculties have worked on livestock disease and production, game animals, and species preservation. Medical faculty have addressed the pathology, epidemiology, pharmacology, and treatment of pressing tropical diseases—HIV/AIDS, malaria, schistosomiasis, onchocerciasis, hypertension, and elephantiasis. Social scientists have initiated and worked on dozens of projects on democratization and civil society, gender, environment, natural resource and water management, fishing peoples, health delivery, journalism and communications, development policy, globalization, and U.S. foreign policy. Education

faculty have worked especially on African higher education administration and effective classroom practice across the continent. And the humanities faculty conduct research on African and Middle Eastern literature and film, history, religions, languages, language pedagogy, philosophy, and music.

The faculty at MSU have applied strong pro-Africa standards to work in Africa, having produced the first U.S. guidelines for ethics in research and in higher education partnerships. The faculty and students also have a history of vigorously supporting human rights and majority rule throughout Africa. Out of this concern, in 1978 MSU was the first university to divest itself of the stockholdings of U.S. corporations continuing to operate in apartheid South Africa. The African Studies Center faculty also voted not to cooperate with or work in South Africa as long as apartheid held sway. In recent years, the center mounted an African Higher Education Partnerships Initiative to give support to African universities.

MSU's Africana Library Collection, one of the leading Africana collections in the United States, supports the university's research on Africa, as do the large collections of art and artifacts in the MSU Museum and MSU Kresge Art Museum. MSU has taken the lead in disseminating African information internationally through a number of websites on African media, African higher education, African academic journals online, and more.

MSU's outreach program on Africa is the largest in the nation, including programs for seventy-five universities and four-year colleges and twenty-nine community and junior colleges, focused on how to improve teaching about Africa for undergraduate students. Outreach to school teachers, students, administrators, and board members includes resources such as Exploring Africa, an online secondary school curriculum. The African Studies Center also hosts the African Media Program, with a database of 11,000 films and videotapes for schools and colleges. Outreach to state and federal legislators links Africanist scholarship to U.S. policy making on Africa, and all of the above, as well as many other resources, are available to the general public, media, and business.

DAVID WILEY
Director, African Studies Center

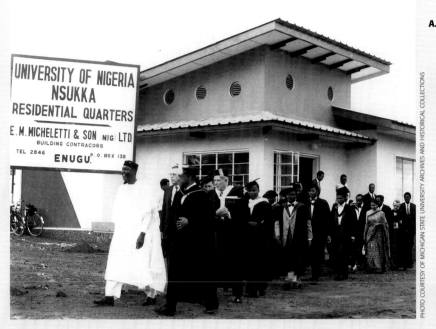

A.

PHOTO COURTESY OF MICHIGAN STATE UNIVERSITY ARCHIVES AND HISTORICAL COLLECTIONS

B.

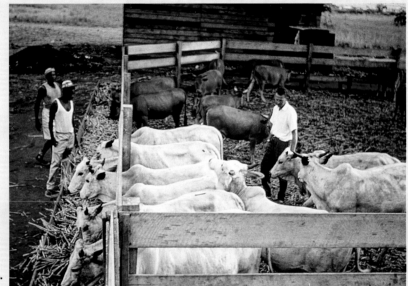

PHOTO COURTESY OF GEORGE AXINN

C.

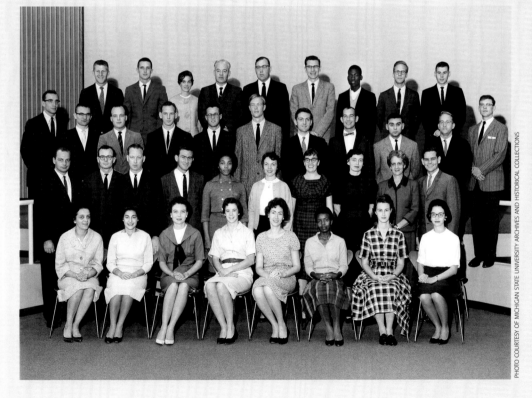

PHOTO COURTESY OF MICHIGAN STATE UNIVERSITY ARCHIVES AND HISTORICAL COLLECTIONS

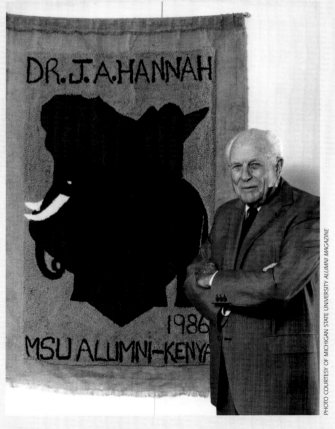

D.

PHOTO COURTESY OF MICHIGAN STATE UNIVERSITY ALUMNI MAGAZINE

A. University Chancellor Nnamdi Azikiwe and Vice Chancellor George Johnson (on loan from MSU's College of Education) lead the opening convocation procession of the University of Nigeria, Nsukka, in 1960. They are accompanied by MSU President John Hannah and other university and government officials. MSU was broadly involved in the establishment of this comprehensive land-grant model institution, the first such university in Africa. Between 1960 and the 1967 civil war that destroyed most of the university, MSU sent 148 faculty members, staff, and administrators on short- and long-term assignments in Nsukka.

B. Hugh Henderson, Animal Science (*in cow pen*), and Nigerian farm hands (*left*), tend cattle on the University of Nigeria Nsukka campus around 1963. This photograph was taken by George Axinn. Now retired from MSU's Department of Resource Development, Axinn was coordinator of the MSU/University of Nigeria program between 1961 and 1965, at the request of President Hannah and ISP Dean Glen Taggart. In 1965 he became "chief of party" for MSU in Nsukka, and prior to leaving in 1967 he fulfilled additional temporary roles at the University, including registrar and acting vice-chancellor. He was evacuated along with all other MSU personnel at the onset of the Biafran War.

C. Nigeria was one of the primary countries that volunteers were assigned to in the newly formed Peace Corps. This photograph shows a group of Peace Corps trainees and training staff on the MSU campus in 1961. According to I. M. "Mac" Destler, a member of the group (*top row, second from left*), thirty of the members of this group were assigned to the University of Nigeria, Nsukka, in November of that year. Roger Landrum (*third row, fourth from left*) was an MSU graduate student when he was selected by the Peace Corps for this assignment. John P. "Jack" Kaechele (*third row, fourth from right*) graduated from MSU in 1961 with a B.A. in accounting. Over the years, MSU has been one of the top sources of Peace Corps volunteers, with around 2,000 alumni having served in scores of countries around the world.

D. In 1986, MSU alumni in Kenya presented President Emeritus John Hannah with this tapestry in honor of his international vision during his twenty-eight-year tenure. According to the summer 1986 issue of the *Alumni Magazine*, which published this photograph, the tapestry was woven by Julie K. Ramtu of Nairobi, a 1969 MSU graduate. Under the leadership of Hannah, who was president between 1941 and 1969, the institution grew in size and scope, became a university, and set an internationalization agenda that was the foundation for a half century of international involvements.

E. / F. In the mid 1980s Michael Bratton, Political Science, was in Zimbabwe on a post-doctoral fellowship from the Rockefeller Foundation for applied research on farmer organizations and food production. The fellowship supported his analyzing the role of organizational factors in food production and marketing, as well as his managing a pilot project promoting farmer groups as a vehicle for agricultural extension in Wedza District, Mashonaland East. These two project-related photographs were taken by the late Kate Truscott, who was assigned to the project as an official of AGRITEX, the Zimbabwean government agricultural extension service. In one photograph, taken in 1984, women in a farmer group are seen winnowing *mhunga* (bulrush millet) on Wedza communal land. In the other, taken in 1983, members of a farmer group on Sabi communal land, Buhera District, are shown at a meeting with members of the AGRITEX Monitoring and Evaluation section. Women also attended the meeting, but were seated outside the frame of this particular photograph.

G. The Afrobarometer is a survey research project that conducts, analyzes, and publishes a series of national public attitude surveys on democracy, markets, and civil society in sixteen African countries. During the most recent round of surveys, made public in March 2004, over 23,000 interviews were conducted. MSU is one of three international Afrobarometer partners, the other two being the Institute for Democracy in South Africa and the Ghana Center for Democratic Development. Michael Bratton is the project director. In this photograph, Afrobarometer interviewer Fatma Mote conducts an interview with a Giriama villager in the Kenyan village of Mzambarauni. Tom Wolf, an independent consultant who coordinated interviewing in that area, took the photograph in 2003.

H. John Staatz (*right*), Agricultural Economics, examines sorghum plants during a development trip to Mali in 2001. He was joined by Larry Hamm, Agricultural Economics, who took this photograph. Also pictured are Mbaye Yade (*left*), an agricultural economist based in Mali, who leads MSU's West Africa Regional Project on Food Security, and Karamoko Soumounou, a Malian farm leader and the owner of the farm on which this improved variety of sorghum was grown. Under the leadership of Staatz and colleague Michael Weber, Agricultural Economics, MSU has undertaken a series of three related food security projects since 1984, funded by USAID. The current project, Food Security III, was funded in 2002 for up to ten years. The purpose of the project is to apply the research of MSU faculty and graduate students and African colleagues "to promote rapid and sustainable agricultural growth as a means to cut hunger and poverty" in several African countries. Since the 1960s numerous other MSU faculty members and graduate students have completed important food security work in Africa.

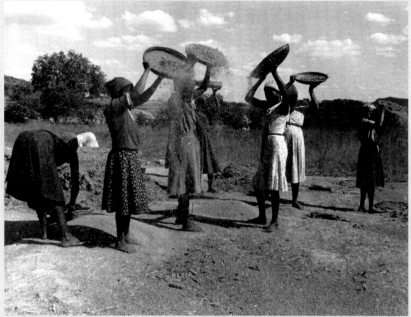

E.

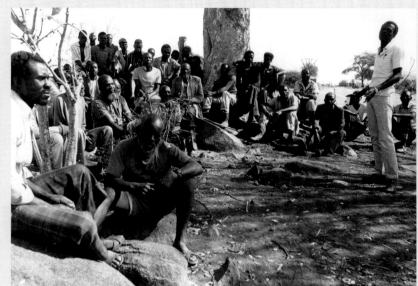

F.

G.

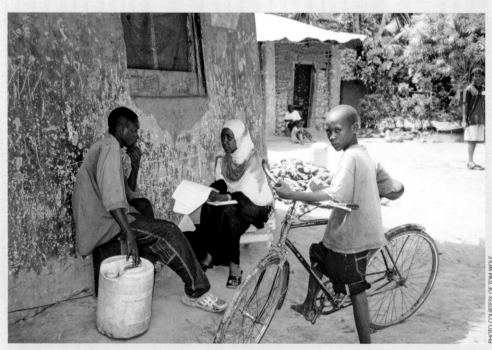

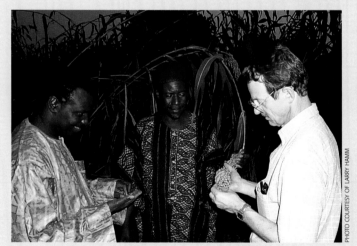

H.

PHOTO COURTESY OF MICHAEL BRATTON

PHOTO COURTESY OF MICHAEL BRATTON

PHOTO COURTESY OF TOM WOLF

PHOTO COURTESY OF LARRY HAMM

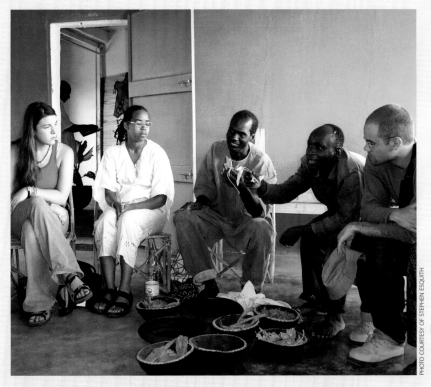

PHOTO COURTESY OF STEPHEN ESQUITH

I.

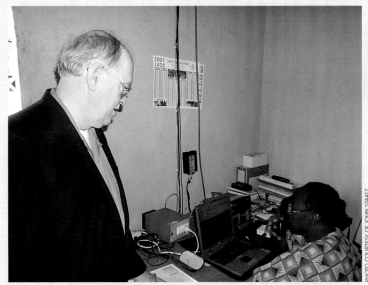

PHOTO COURTESY OF JOHN STAATZ

J.

K.

L.

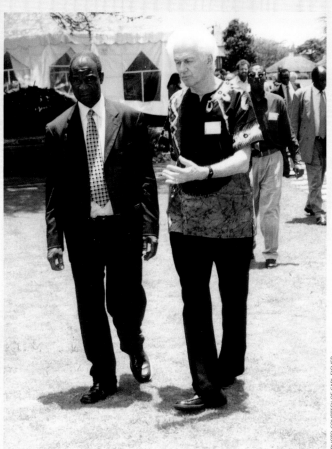

PHOTO COURTESY OF CARL EICHER

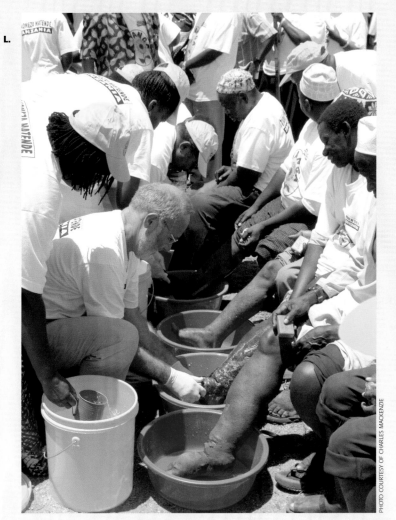

PHOTO COURTESY OF CHARLES MACKENZIE

I. One of the new MSU study abroad programs for summer 2004 was Ethics and Development in Mali. Led by Stephen Esquith, Philosophy, five MSU students and three students from other institutions studied Mali's culture, language, and society, and the ethical complexity of development issues in that country. Courses were taught by Esquith, as well as Christine Worland and Yobi Guindo, both of whom hold MSU degrees. In this photograph, taken by Esquith, students are shown working in the Kasobane fabric art atelier. Their instructor, Boubacar Doumbia, one of the founding members of the Kasobane Atelier collective, is explaining some of the traditional techniques of using natural pigments to color cotton fabric.

J. MSU President Peter McPherson visits a site of the Mali Market Information Support Project in January 2003. One of the co-chairs of the Partnership to Cut Hunger and Poverty in Africa, McPherson visited Mali at the invitation of fellow co-chair Alpha Oumar Konare, who was president of Mali at the time. MSU, through its participation in Food Security Cooperative Agreements, played a key role in the development of the agricultural market information system, which in 2004 was declared by the Development Gateway Foundation to be one of the eight most exemplary applications of new information technology in developing countries over the past decade. The system links a network of market information stations throughout the country to bring current information to farmers in remote areas, allowing them to base farming decisions on current market conditions. Also pictured is Moulaye Ely Diarra, director of computer services for the system and a former MSU student. The photograph was taken by John Staatz, Agricultural Economics.

K. Before retiring in 2000, Carl Eicher had a long and distinguished career as a professor in MSU's Department of Agricultural Economics. He was involved in the University of Nigeria's Economic Development Institute in the 1960s and continued to work on agricultural development and food security issues throughout his career. In this photograph, Eicher (*right*) is shown walking with Ugandan Minister of Agriculture Wilberforce Kisamba-Mugerwa at meetings in Nairobi, Kenya, in May 2004. With financial support of the W. K. Kellogg Foundation, Eicher is currently involved in research on science and technology policy for agriculture in Africa.

L. Charles Mackenzie, Pathobiology and Diagnostic Investigations, is shown assisting patients afflicted with lymphatic filariasis, commonly know as elephantiasis, in Mtwara, Tanzania. Mackenzie spent 2000 on sabbatical working with drug companies to arrange for them to donate drugs that can prevent the disease. He leads MSU's involvement in the Global Alliance for the Elimination of Lymphatic Filariasis, an organization that received a five-year grant of $20 million from the Bill and Melinda Gates Foundation in 2001. The Global Alliance has set a goal of providing over two billion doses of antiparasitic drugs to the people who need them. Recent collaboration between MSU and the Tanzanian Ministry of Health Filariasis Control Program has resulted in the treatment of around five million people.

M. Terrie Taylor, Internal Medicine, spends half of each year in Blantyre, Malawi's largest city, treating pediatric patients suffering from malaria and studying the disease. She directs the Blantyre Malaria Project and conducts her work in the research wards at the Queen Elizabeth Memorial Hospital, which serves as a teaching hospital for the Malawi College of Medicine. Each year several students from MSU's Colleges of Osteopathic and Human Medicine spend time at the hospital working alongside Malawian medical students on the general wards. When Taylor returns to MSU in June, after Malawi's rainy season has ended, she analyzes her data, writes articles, and teaches students on campus. In this photograph, taken by colleague Fred MacInnes, she attends to a young malaria patient while the patient's father looks on.

N. MSU's African Studies Center (ASC) and MATRIX: Humanities and Social Sciences Online have collaborated on several projects designed to expand Internet access in various African countries. In this photograph, taken by ASC Director David Wiley in 2002, Thabo Leshoro of the University of Zululand instructs a Durban Institute of Technology trainee in Durban, South Africa, as she prepares to assist communities and community organizations to develop their own websites to present their histories, their resources, and their needs. Leshoro, himself, received website development training at MSU through MSU's South Africa National Cultural Heritage Project.

O. For more than twenty-five years, scientists from MSU and East African institutions have collaborated on research on land use change in East Africa. Recent projects include LUCID (Land Use Change, Impacts and Dynamics), funded by the Global Environment Facility, and CLIP (Climate and Land Interactions Project), funded by the National Science Foundation. The research team shares survey findings with communities at feedback workshops based on Paulo Friere's participatory *conscientização* approach, where results are presented, interpretations are discussed, and future land use options are considered. In this 1978 photograph taken in Kenya by team member David Campbell, Geography, a Maasai elder studies a "code" depicting drought conditions and discusses it with workshop facilitator Anthony T. Mepukori. Now senior chief, Loitokitok Division, Mepukori continues to participate in the research.

P. Rebecca Curry and Katie Krupansky, summer 2002 participants in the Pre-Internship Teaching in South Africa study abroad program, use English and Zulu in a first-grade classroom. They were working at the Sitholinhlanhla Primary School in Richards Bay, north of Durban. The program was established to enable MSU students who have completed a bachelor's degree in teacher education to apply their skills in an international setting and to learn about education in a foreign country. This photograph was taken by Anne Schneller, International Studies in Education, who developed and co-directs this program. She has been involved in the development of numerous international projects and study abroad programs for the College of Education.

M.

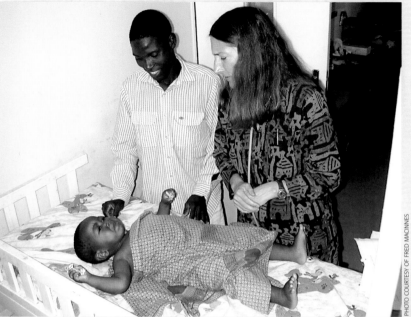

PHOTO COURTESY OF FRED MACINNES

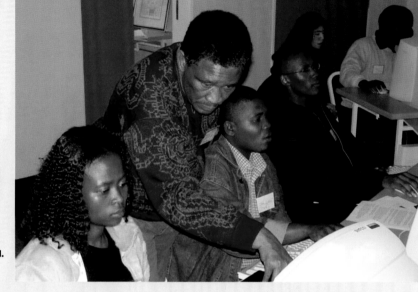

PHOTO COURTESY OF DAVID WILEY

O.

N.

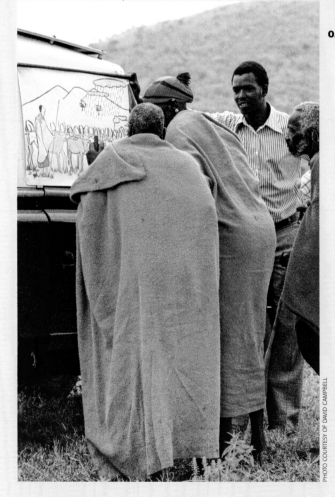

PHOTO COURTESY OF DAVID CAMPBELL

P.

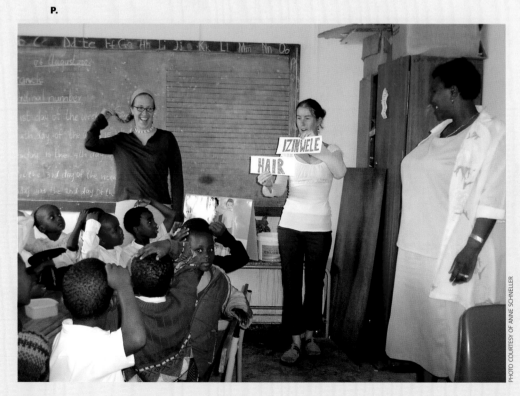

PHOTO COURTESY OF ANNE SCHNELLER

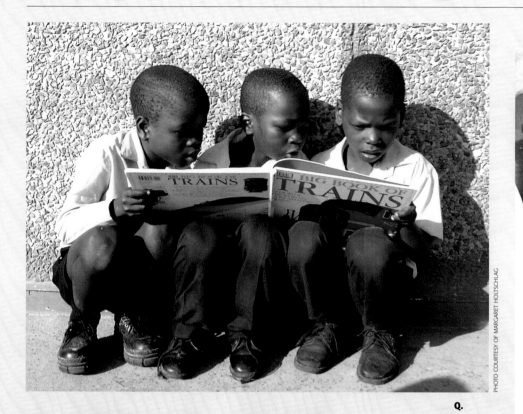

PHOTO COURTESY OF MARGARET HOLTSCHLAG

Q.

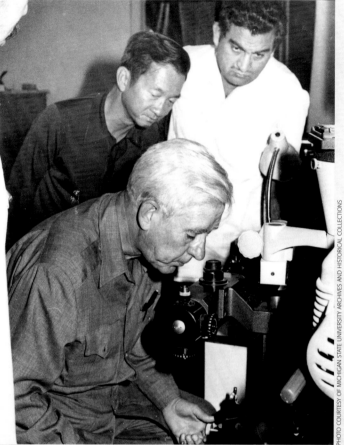

PHOTO COURTESY OF MICHIGAN STATE UNIVERSITY ARCHIVES AND HISTORICAL COLLECTIONS

S.

R.

T.

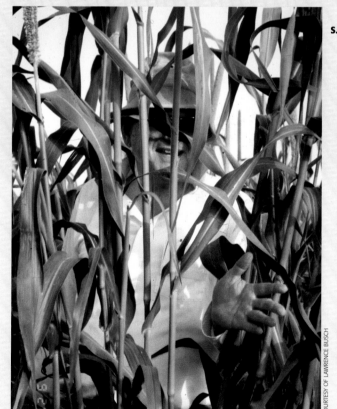

PHOTO COURTESY OF LAWRENCE BUSCH

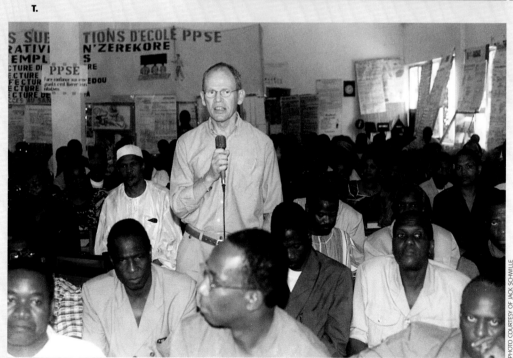

PHOTO COURTESY OF JACK SCHWILLE

Q. Participants in the 2003 Pre-Internship Teaching in South Africa study abroad program brought books, donated by College of Education faculty, for the libraries of the schools they taught in. In this photograph, students at Enhlanzini Primary School in Richards Bay, South Africa, peruse a book about trains. The photographer, Margaret Holtschlag, is a Lansing-area teacher who has been active in the LATTICE (Linking All Types of Teachers to International Cross-Cultural Education) Program, a collaboration between MSU and area school districts.

R. Ralph Turner, who was a forensic scientist in MSU's School of Criminal Justice, taught and consulted in many countries around the world. During the 1960s and 1970s he was a consultant to the Saudi royal family on issues related to Saudi Arabia's criminal justice system. In this photograph he instructs laboratory technicians as a visiting professor at the University of Riyadh.

S. In 1999 Lawrence Busch, Sociology, was in Mali on an external evaluation panel for the International Grain Sorghum Pearl Millet Collaborative Research Support Program. In this photograph he peers out from a sorghum field. Busch has long been involved in international development research and project work, and he currently directs the Institute for Food and Agricultural Standards at MSU. Recently his leadership has been crucial to MSU's involvement in two important USAID-funded projects designed to enable producers in developing countries to participate more fully in the emerging global economy by selling their agricultural products directly to Western supermarkets.

T. Between 1993 and 2002 the College of Education provided all of the external technical assistance in the World Bank–funded Guinea Small Grants Staff Development and School Improvement program. This program provided organizational support and incentives for teams of primary school teachers in Guinea to carry out their own professional development and school improvement projects. It was the first such program on a national scale in Guinea. In 2000, after some 1,000 projects had been funded, a national dissemination conference was held at the University of Conakry in the country's capital city. The conference brought together around fifty teams of teachers, whose projects had been selected at regional conferences throughout Guinea, to present their results to each other and to education officials. The teachers, from both urban and rural settings, had never had such an opportunity to be recognized for their capabilities and achievements. In this photograph, Jack Schwille, International Studies in Education, reacts to one of the presentations. He and Martial Dembélé, MSU Ph.D. from Burkina Faso, were the principal leaders of the MSU team.

U. / V. In 1999 the MSU Press published *Letters from Robben Island* by Ahmed Kathrada, a book describing the author's imprisonment in South Africa with Nelson Mandela and others. In conjunction with the fall 1999 U.S. book tour, Peter Glendinning, Art, was asked to display his South African portrait series at the South African Embassy in Washington, D.C., and the South African Consulate in New York City. Glendinning had created the series of fifteen photographs while he was a visiting artist at three South African *technikons* (comprehensive technical colleges) in March 1999. The first photograph shows Glendinning with South African Ambassador Sheila Sisulu in front of a display of the portrait series at the South African Embassy in Washington, D.C. The second photograph, one of Glendinning's portraits, depicts Meshak Mesuku, a Swazi prince who is also an outstanding ceramist. According to Glendinning, Mesuku "is well known in Port Elizabeth and has a dedication to bringing the ceramic arts to the youth as a means of both expression and income."

W. Students on the summer 1998 MSU Jewish Studies in Jerusalem, Israel, study abroad program take a break during a field trip in the Judean Desert. Led by an archeologist, they were exploring archeological traces of how Jews drew water from wells in the desert. The photograph was taken by Ken Waltzer, Center for Integrative Studies in Arts and Humanities and James Madison College, who was the program's faculty leader that year. The program was based at Hebrew University's Rothberg International School and focused on ancient as well as modern Jewish life.

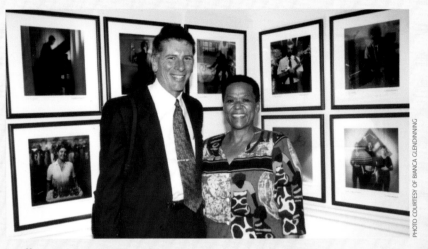

U.

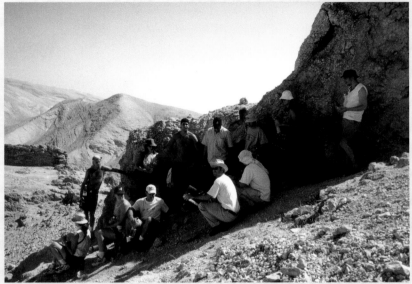

W.

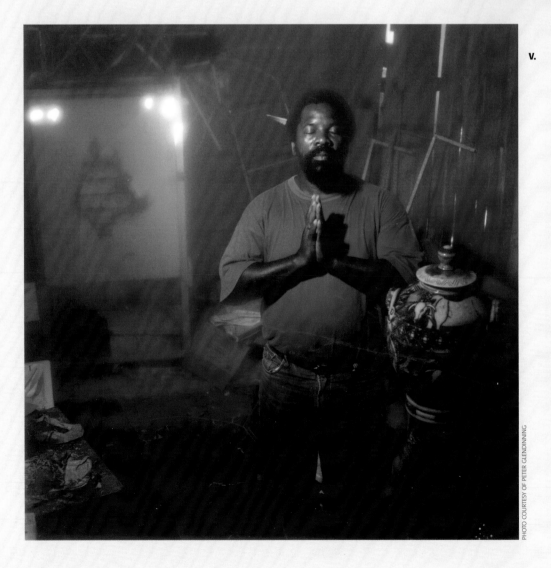

V.

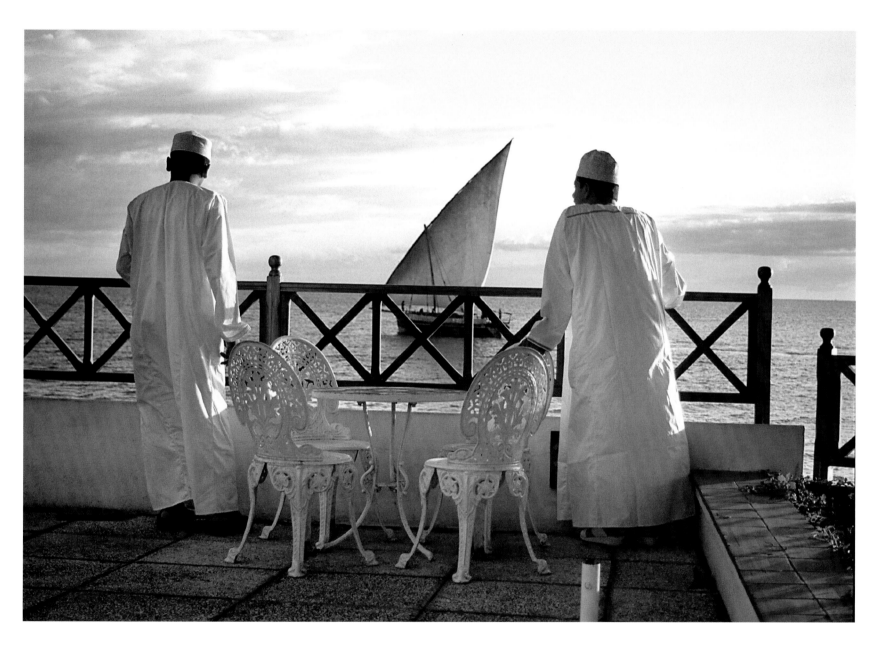

While enjoying a sundowner on the terrace of the Serena Zanzibar Inn, I was sure I could get a wonderful shot of a dhow sailing past as the sun was setting. Two Muslim gentlemen strolling by also decided to savor the moment.

"Friends Sharing a Peaceful Moment"
2002 Faculty/Staff First Place
John Funkhouser, *Tanzania, 2002*

This image gives a glimpse into the cultural inter-connectings between East Africa and the Indian Ocean cultural spheres. Women in Lamu, and on the Swahili coast more generally, continue to celebrate and refine the female art of painting with and wearing henna. This picture was taken at a henna painting competition, where the greatest local artists exhibited their innovative local designs and homages to traditional designs.

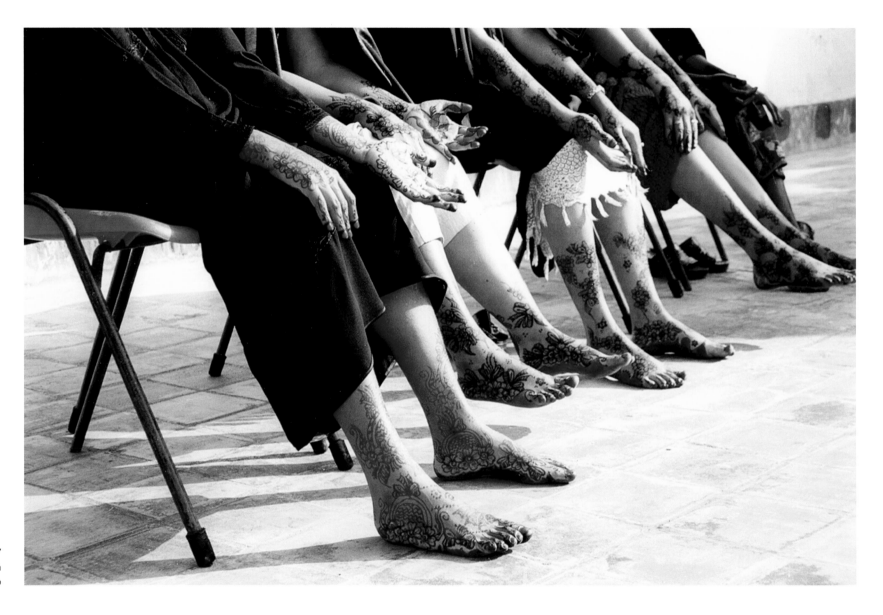

"The Art of Henna I"
2000 Faculty/Staff Honorable Mention
Prita Meier, *Lamu, Kenya, 2000*

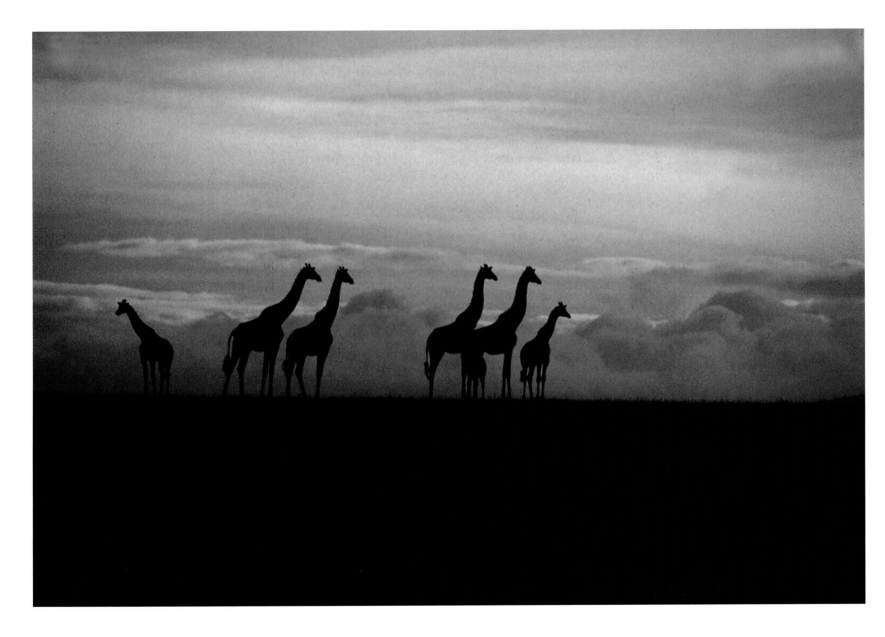

This photo was taken in Kenya's Masai Mara National Reserve, the site of MSU's Behavioral Ecology of African Mammals course. The Mara is part of the Serengeti ecosystem, and each year hundreds of thousands of wildebeest (and Thompson's gazelles and zebras) pass through in their annual migration. My photo was taken before the wildebeest arrived, when the plains were relatively empty but for this group of giraffes.

"Under African Skies"
2001 Student Third Place
Anne Engh, *Kenya, 2000*

Our study abroad group visited the small rural town of Chiweshe, Zimbabwe, where we stayed for three days with local families. We helped to repaint the St. Alban's Church, which had not been painted in many years. In this particular scene, the girls from the school greeted us with some traditional dances. I took this photo of the sea of young boys who observed these dances with us.

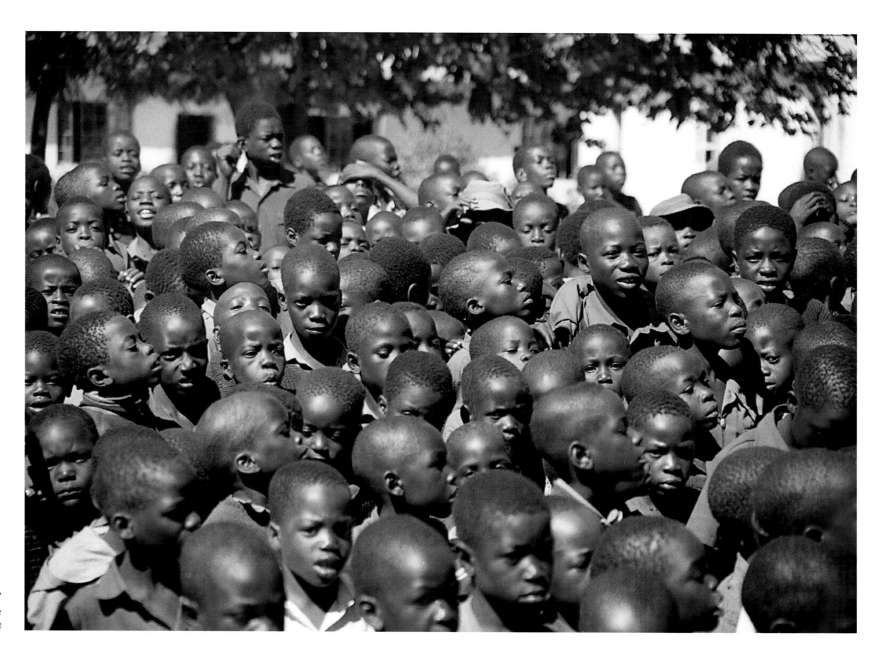

"Eager Minds"
2002 Student Second Place
Jessica Mills, *Zimbabwe, 1998*

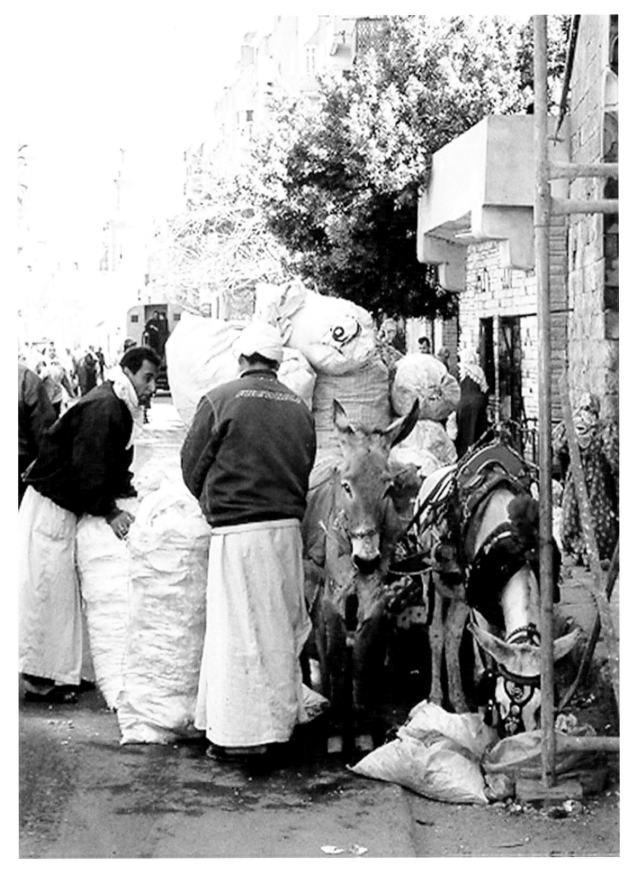

Old Cairo is a section of Cairo, Egypt, where the streets are narrow and the buildings date to the eighteenth century and even before. People use donkeys as pack animals to transport goods around the narrow streets.

"Old Cairo Street"
2001 Alumni Honorable Mention
Pamela Luttig, *Egypt, 2001*

I took this photo in the depths of the labyrinthine medina in Fez, Morocco. I had been working in Morocco for about a year as a Peace Corps Volunteer and was in the "big city" for a weekend at the time this photo was taken.

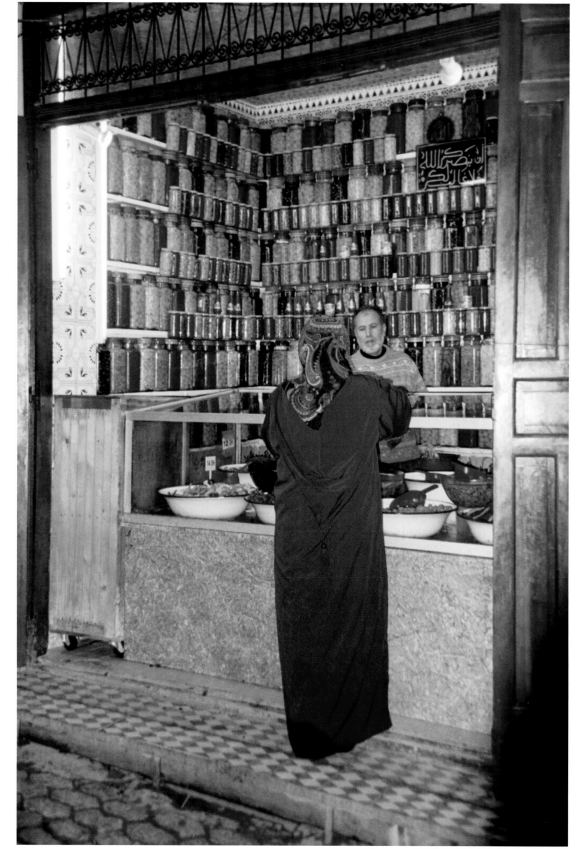

"Pick a Jar, Any Jar"
2003 Faculty/Staff Third Place
Joy Campbell, *Morocco, 1999*

This photo was taken on a side street in Dakar while I was in Senegal for a web design workshop with women involved in the Internet Women's Democratic Organizing project with MATRIX. The young man in the photo had been standing watching the traffic pass by.

Untitled
2003 Faculty/Staff Honorable Mention
Marit Dewhurst, *Senegal, 2003*

To help fund education for their village children, Maasai open their compounds to visits by tourists. In this village on the edge of the Serengeti in Tanzania, our guide was a well-spoken young man who was normally away at college studying land management and ecology. His father, the village chief, and other family members are the subjects of this photo.

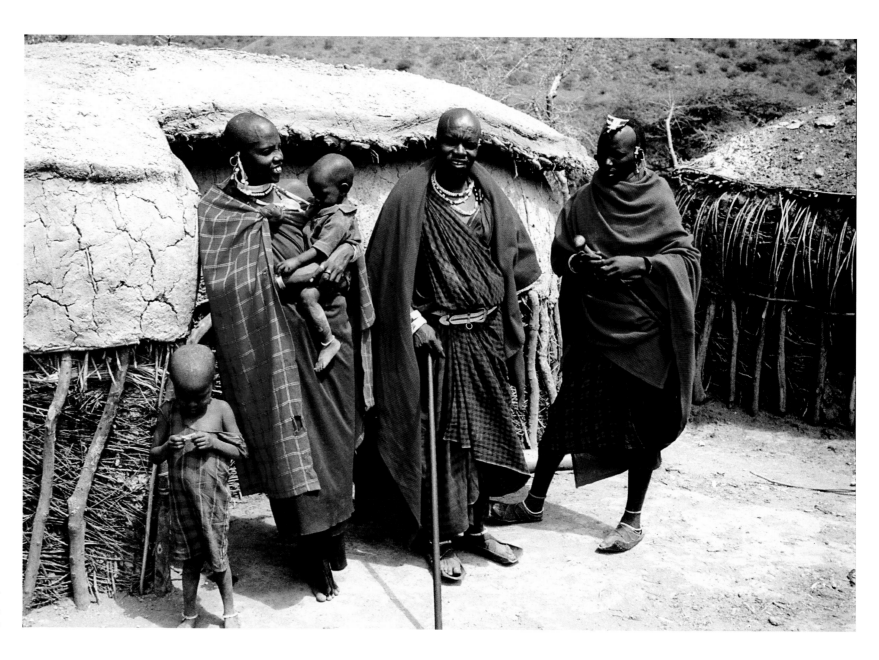

"Maasai Family"
2002 Faculty/Staff Honorable Mention
John Funkhouser, *Tanzania, 2002*

This woman was interviewed in the village of Kouyewa during a research project on wild plant foods in the Republic of Niger. She provided important historical information on wild plant foods that are eaten by the local population. Residents of the region often face food and water shortages, and wild plant foods play an important role in local diets.

"New Friend from Kouyewa"
2002 Alumni Honorable Mention
Robert Glew, *Niger, 2002*

This is a portrait of local children in a village outside of Quarzazette, in the center of Morocco. We did not know the children, they actually posed of their own accord . . . then proceeded to ask us for money. It was just one of several instances where children, even in remote villages, used their charm and wit to create income opportunities for their families and enrich our traveling experience.

"Moroccan Children"
1999 Student Honorable Mention
Erin Hill, *Morocco, 1999*

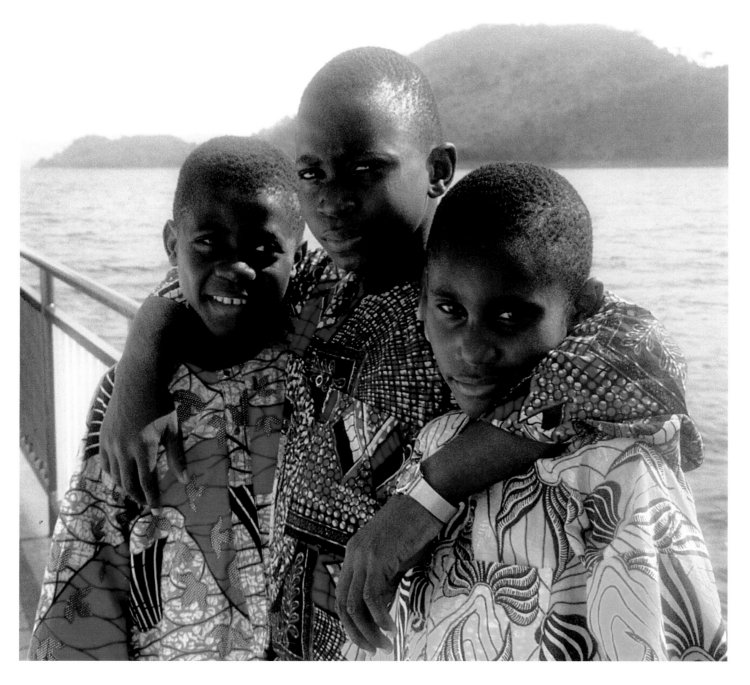

This photo was taken on a Sunday cruise on Lake Volta, where local families were taking a holiday. I came down the stairs from the upper deck and saw the boys standing by the rail, joking and talking with one another. What I like about the picture is the closeness of the group—in their Sunday finery, having fun together. The reason that I was in Ghana was to coordinate an MSU-sponsored study tour of Craft Traditions and Family Life in Ghana following the International Federation for Home Economics International Congress in July 2000.

"Brothers"
2000 Faculty/Staff Honorable Mention
Mary Andrews, *Lake Volta, Ghana, 2000*

In 1998 I went to visit Morocco, our neighbor and a big mystery for Spaniards. While walking in the Zoco, a big labyrinth of narrow streets, smells, and sounds, I noticed the woman in the picture. She called my attention because she was so serene, so peaceful, and I ended up taking a picture of this anonymous woman carrying water in a noisy street.

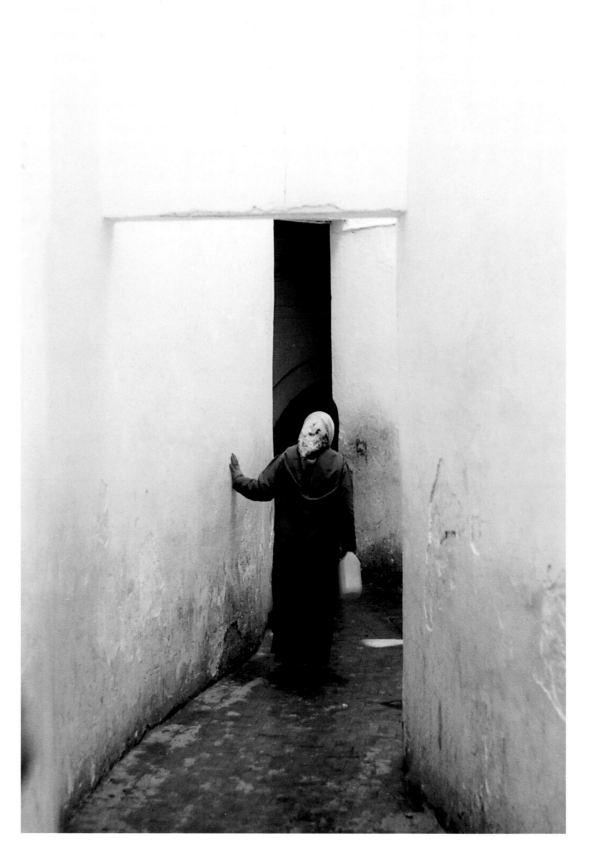

"Woman Carrying Water"
2002 Student Honorable Mention
Natalia Ruiz-Rubio, *Morocco, 1998*

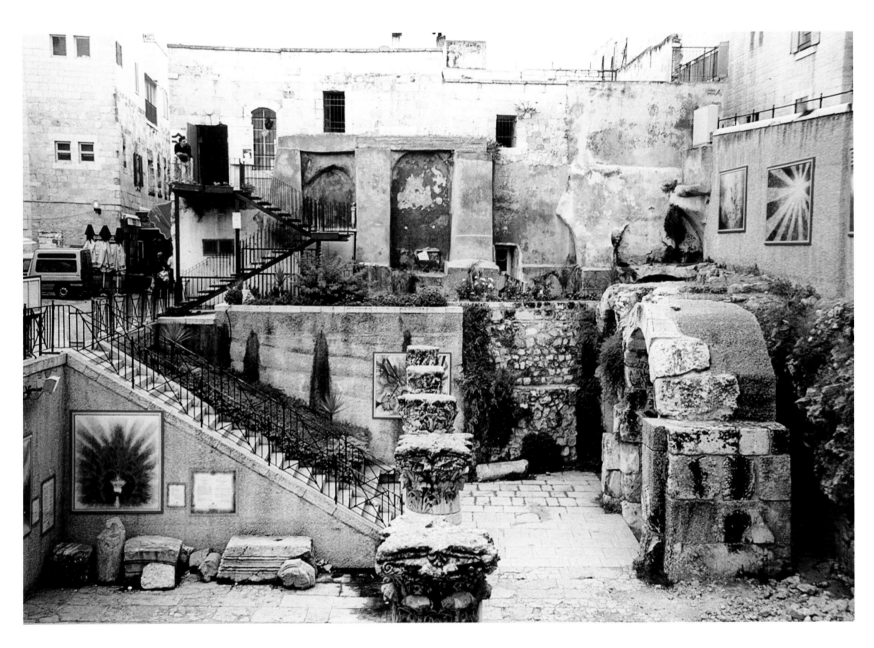

My photo shows a "niche" in the Old City of Jerusalem, where excavation has revealed remnants of the city in Roman times and with Roman architecture. A twenty-first-century artist has set up an exhibit there—makes a nice old/new contrast!

"Roman Ruins and Modern Art"
2000 Faculty/Staff Honorable Mention
Talbott Huey, *Jerusalem, Israel, 2000*

"Vultures Nesting at Sunset" was taken at the end of a late afternoon game drive in the Masai Mara Game Reserve of Kenya. Messy carrion feeders by day, the vultures seemed at once sublime and somewhat majestic as they settled in for the night in an acacia tree.

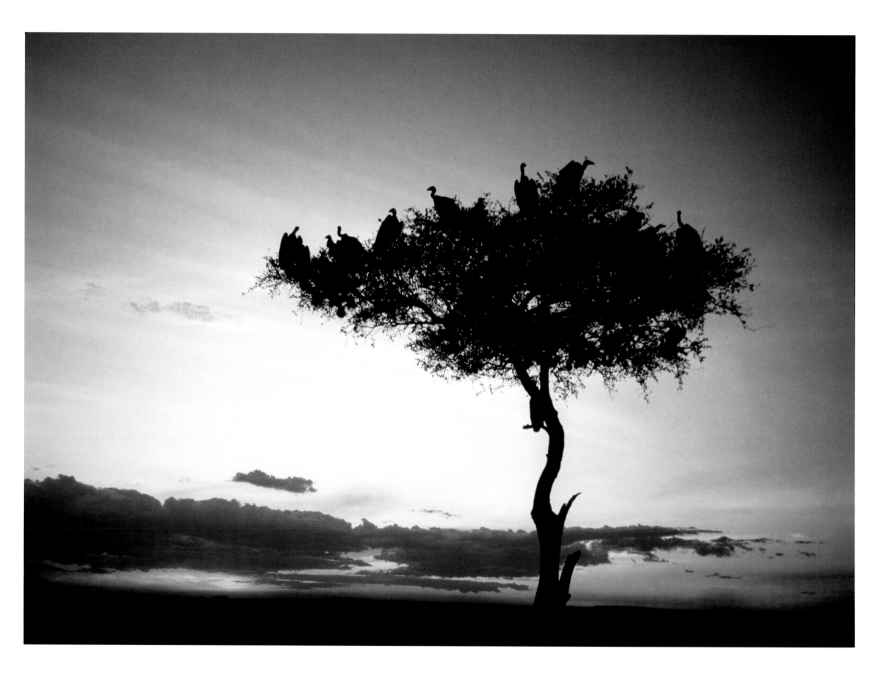

"Vultures Nesting at Sunset"
2003 Faculty/Staff Honorable Mention
Andrea Funkhouser, *Kenya, 2001*

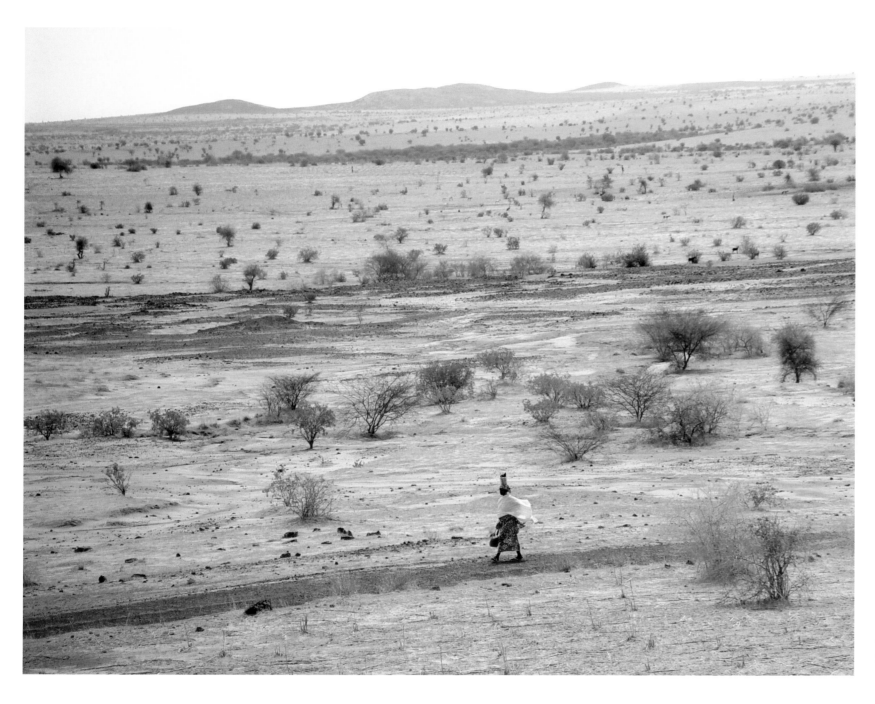

This photograph was taken on the road between Sabonkafi and Gangara in the Republic of Niger. The area represents the transitional zone between farmable and non-farmable land in central Niger. Annual rainfall often does not total the 250 mm needed to produce a crop of millet, the staple grain of the area.

"Long Walk Home"
2003 Alumni Second Place
Robert Glew, *Niger, 2002*

MSU has a proud tradition of research, study, and scholarship in the Americas. Individual researchers, various thematic international institutes, and two area studies centers, the Center for Latin American and Caribbean Studies (CLACS) and the Canadian Studies Centre, have helped to create dynamic programs that have fostered sophisticated study of the hemisphere as well as involvement in regional issues and problem solving.

The Latin American Studies Center (the initial name of CLACS) was an outgrowth of MSU involvement in several Latin American countries, such as Colombia, Costa Rica, and Brazil, by faculty from several departments. It was established in 1963 by faculty members who had collaborated with Brazilian colleagues and the Getúlio Vargas Institute in creating and improving schools of business administration in Brazil. The schools they helped to create in Brazil, including the prestigious Escola de Aministração de Emprêsas de São Paulo, are among the top business schools in that country. CLACS has since administered many other major grants and projects in Latin America. One of the most significant of these was a Brazilian program in the 1970s to train advanced agricultural students, to upgrade management of Brazilian universities, and to strengthen Brazilian agricultural faculty. MSU organized and led a number of other U.S. universities in this U.S. government–funded project.

MSU's efforts in Latin America extend beyond educational institution-building projects. For example, a major reforestation project, funded through a USAID grant, was undertaken in the Dominican Republic. Environmental concerns also motivated a project that used geographic information system technology to study land use and change in the Amazon region. Globalization has brought about enormous changes in food marketing, and MSU researchers are at the forefront of research on these changes in Latin America, as well as in the related areas of food standards and toxicology. Issues of the environment and food safety are related to issues of water quality and health. A recent Hewlett Foundation grant to MSU has provided for the systematic and comparative study of water quality issues in Latin America. Still other foundations have aided MSU researchers in the study of the pre-history of west central Mexico of gender and identity in Latin America.

In 1991 the United States Department of Education through its Title VI program designated and funded CLACS as an Undergraduate Center of Excellence. Along with this award, CLACS also received Foreign Language and Area Studies fellowships for graduate student language training. Designation as a Title VI recipient placed MSU in the first tier of Latin American studies and opened the door for future funding. CLACS subsequently was awarded the prestigious Tinker Field Research Grant Fellowship for graduate research and travel, as well as a Department of Education Undergraduate International Studies and Foreign Language Program grant.

As a land-grant institution, MSU has always shared its expertise and worked with Latin American institutions. For example, MSU was the first U.S. university invited to work with the United Nations Economic Commission for Latin America and the Caribbean. By invitation of the U.S. Department of Education, MSU hosted a conference in Mexico for ninety U.S. universities on the topic of globalization and how it can best be taught. East Lansing was the location for workshops on the plight of small agricultural producers in Mexico and continuing discussions and analysis of the impacts of the North American Free Trade Agreement. The African Diaspora and its implications for Latin America has been a major subject of research and is the topic of a unique publication series issued from the university. In the area of communication, the School of Journalism held a conference on freedom of the press in Latin America to honor MSU Professor Mary Gardner, the MSU journalism professor whose work with Mexican newspapers had an important effect in professionalizing the Mexican press.

MSU's Latin American involvement also includes sending MSU students to Latin America to gain direct experience in the region. Today MSU offers thirty-seven different study abroad programs in Latin America, including at least one program in almost every nation. Programs range from full-year immersion to the new one-week freshmen seminars that are designed to give freshmen a first taste of the region. Latin Americanist faculty at MSU have developed these programs, which contribute to making MSU a national leader in study abroad.

Around the state of Michigan, MSU's Latin America outreach efforts have benefited business, industry, government, and especially K-12 education. MSU Extension and CLACS have each sponsored a Fulbright-Hays Group Project Abroad for Michigan teachers to participate in study tours to Mexico. CLACS has also developed the Latin American School and Educational Resources (LASER) website, which provides electronic resources for K-12 teachers. Supplementing this work is a major book published by the National Council for the Social Studies Press offering Latin America and Canada background information for teachers

MSU interest in Canada reflects the deep involvement of President John Hannah, who in the 1950s worked with the U.S. and Canadian governments on the development of the Distant Early Warning Line radar and communication system to monitor Arctic airspace. Hannah recognized the need for Americans to better understand Canada. In the early 1950s he encouraged the establishment of a small interdisciplinary discussion group of faculty and graduate students interested in Canadian issues, the Committee for Canadian-American Studies. It was perhaps the very first group with an area studies focus at MSU, and it eventually evolved into one of the first Canadian Studies centers in the United States. MSU faculty also were instrumental in the formation of the Association for Canadian Studies in the United States. Canadian scholars, such as the poet and literary critic A. J. M. Smith, have been members of the MSU faculty, and many prominent Canadian scholars, government officials, and business leaders have participated in conferences hosted by MSU.

Each academic year the Canadian Studies Centre hosts a prominent Canadian scholar as the Fulbright–Michigan State University Visiting Chair in Canadian Studies. These scholars build relationships within the academic community and bring their expertise to MSU students who, through the Canadian Studies Centre, can participate in internships, freshman seminars, and other study abroad programs in Canada. The MSU Press maintains a strong publishing interest in Canadian Studies, which has been a key element in its publishing program for decades. The MSU Press also distributes works published by several university and small scholarly Canadian publishers, bringing hundreds of titles with Canadian content into the U.S. market annually.

Michigan State University has continued to play a significant role in shaping Canada–U.S. relations, in part due to the background of President McPherson, who, as deputy secretary of the Treasury, was a senior negotiator in the 1988 Canada–U.S. Free Trade Agreement. Ten years later, as MSU president, he hosted the first major conference to review issues related to the agreement. Through an endowment from the Canadian National Railway Company, MSU annually hosts the Canadian National Forum on Canada–U.S. Relations, which brings together students, faculty, government representatives, and business leaders from the United States and Canada to encourage understanding and cooperation on issues of common interest.

PHIL HANDRICK

Acting Director, Canadian Studies Centre

SCOTT WHITEFORD

Director, Center for Latin American and Caribbean Studies

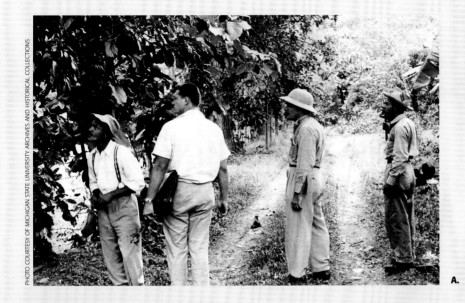

A.

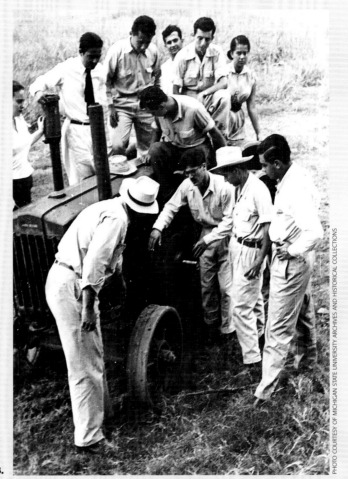

B.

C.

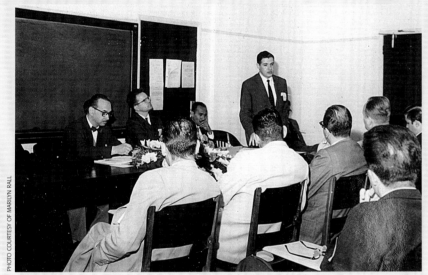

E.

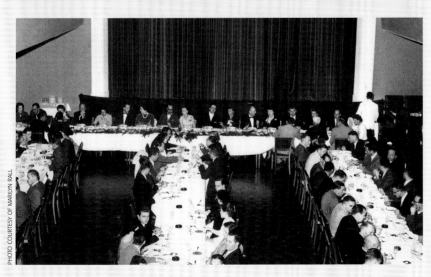

D.

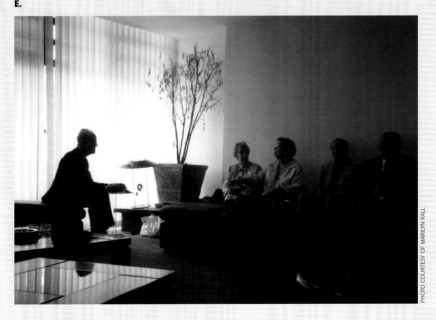

A. / B. One of Michigan State College's earliest technical assistance projects in Latin America was in Colombia, where in the early 1950s the school played a major role in assisting the Universidad Nacional de Colombia's Colleges of Agriculture in Medellín and Palmira in modifying their curricula, broadening their missions, and even establishing a new school of forestry. Under a contract signed in 1951 by MSC (as MSU was then known) and the governments of Colombia and the United States, a number of Michigan State faculty members spent one to two years at the campuses in Colombia, and an even greater number of Colombian faculty and students came to MSC for one-year advanced training programs. The project was financed by the U.S. Technical Cooperation Administration, a precursor of the United States Agency for International Development (USAID). One major outcome of this project was a shift in approach at the Colombian institutions to a more "land-grant" approach, with the development of extension programs, research farm demonstrations, and short courses offering practical training for farmers.

These photographs show Dean Freeland, MSC Forester, with a class studying tropical forest species, and students in a farm machinery class as they learn proper procedure for starting a tractor from Harrison Fisch.

C. / D. / E. MSU was involved in projects leading to the creation of three Brazilian business schools during the 1950s and 1960s. One of these was the Brazil Project in Business Administration (frequently referred to as the Vargas Project due to the involvement of the Brazilian Getúlio Vargas Foundation), which was key to the establishment of the São Paulo School of Business (Escola de Administração de Empresas de São Paulo).

Four MSU business faculty members who were heavily involved in this enterprise during the mid 1950s were Karl Boedecker (first chief of mission), Leonard Rall (second chief of mission), Fritz Harris, and Ole Johnson. They not only helped to found the school but also took on teaching assignments during the early years. Photographs from the family collection of Leonard Rall show Brazilian program participants in a classroom setting in the 1950s (C); the farewell dinner in honor of the MSU faculty, held in June 1958 (D); and celebrants at the fortieth anniversary of the school gathered to rest between events (E). A fiftieth anniversary was celebrated in September 2004.

F. More than a decade after the Vargas Project began, MSU received multi-year grants from USAID for the Latin American Food Marketing Program and the Latin American Market Planning Center. There were project teams in Puerto Rico (1965–66). Brazil (1966–67), Bolivia (1966–67), Colombia (1970), and Costa Rica (1972). This market scene is from the largest site for the project, the northeast region of Brazil. It was taken in 1966 in the city of Vitória in the state of Pernambuco by Robert Nason, currently chair of MSU's Department of Marketing and Supply Chain Management. At that time, he was an MSU Ph.D. student in marketing. According to Nason, "the projects studied the system of food distribution from farm gate to urban consumption and to some degree the reverse flows of non-food goods and technology." The projects were led by Charles Slater, College of Business, and Harold Riley, Agricultural Economics. In 2003 Harold Riley was honored during the sixtieth anniversary of the founding of the Inter-American Institute for Cooperation on Agriculture by being featured in a commemorative book as one of the sixty individuals and institutions in the United States who have contributed the most to progress in agriculture in the Americas during the past sixty years.

G. For more than twenty years, the late MSU Journalism Professor Mary Gardner spent her summers in Monterrey, Mexico, training reporters at *El Norte,* a small local newspaper. The newspaper's current publisher, Alejandro Junco de la Vega, had been a student of hers at the University of Texas. Her contributions are credited with helping *El Norte* grow from the number two newspaper in Monterrey to the number one newspaper and newspaper chain in the entire nation. Junco de la Vega describes Dr. Gardner as the "godmother" of the free press in Mexico. This photograph was taken at the *El Norte* offices in the mid 1980s.

H. / I. Through Plan Sierra, a large nonprofit organization active in the region, MSU faculty were involved for several years in environmental projects in the Dominican Republic that addressed issues of soil and water conservation, reforestation, and garden vegetable production. In the early 1990s an MSU delegation visited this participating school in the mountains of the Dominican Republic. The first photograph shows students in a classroom. The second photograph shows students with members of the delegation: Scott Witter, Resource Development (now part of Community, Agriculture, Recreation, and Resource Studies); MSU President Gordon Guyer and his wife, Norma; MSU Trustee Jack Shingleton and his wife, Helen; ISP Dean Gill-Chin Lim; and Scott Whiteford, Anthropology and director of the Center for Latin American and Caribbean Studies. Witter and Whiteford have also been involved with two Dominican universities on a Rio Yaque del Norte water quality project.

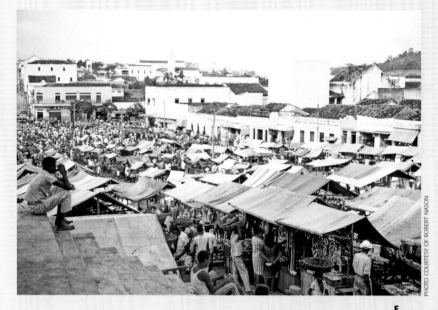

F.

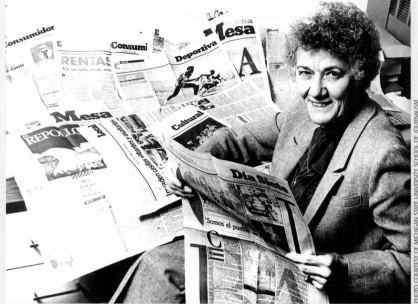

G.

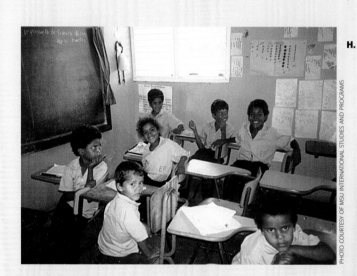

H.

I.

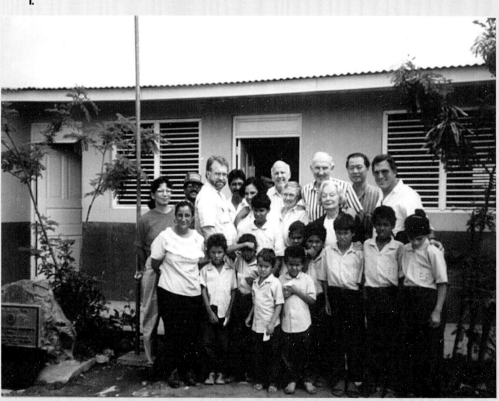

J.

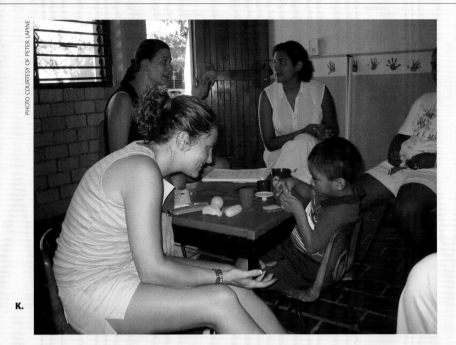

K.

M.

L.

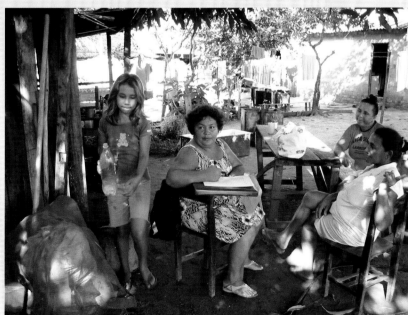

J. John M. Hunter, Economics, was director of the Center for Latin American and Caribbean Studies from the late 1960s to the early 1980s. During that time he was involved in many international projects and in establishing relationships with educational institutions in Latin America. In 1970 he visited a banana processing plant in San Pedro Sula on the east coast of Honduras and shot this "action" photograph of bunches of bananas moving on a conveyor system.

K. Faculty and students in the Department of Audiology and Speech Sciences regularly provide clinical services in two Mexican communities in the state of Yucatán and in Camargo and Playa del Carmen under the auspices of a project led by Peter LaPine, Audiology and Speech Sciences. As of summer 2004 groups have made nine trips and have managed more than 3,000 cases. This August 2003 photograph was taken at the Centro de Atención Múltiple, a school for handicapped children in Playa del Carmen. LaPine paired graduate students Sara Holaly (*foreground*) and Diane Ogiela (*background*) to work with this particular student, who is hearing impaired, as well as with her teacher (*background*) and her mother (*out of photo*).

L. / M. Antoinette WinklerPrins, Geography, carries out research on urban home gardens in the Brazilian Amazon. Her studies demonstrate the importance of women's social networks to household survival in an area undergoing rapid urbanization. She recently completed a year-long investigation of twenty-five households in Santarém, Pará, Brazil, in which an ethnographically trained Amazonian field assistant visited households monthly to document exchanges of germplasm and products for and from home gardens. These photographs, from August 2003, show field assistant Perpetuo de Sousa interviewing women in their home garden and a collection of medicinal plants kept near their owner's house for easy access.

N. This photograph shows a Mexican farm worker loading cotton in the Mexicali Valley in 1996. It was taken by Scott Whiteford, Anthropology, director of the Center for Latin American and Caribbean Studies. He and colleagues in the United States and Mexico are studying that region as they analyze the impacts of the North American Free Trade Agreement (NAFTA) on the Mexican countryside. U.S. price supports for cotton, as well as for other crops, are a source of contention between Mexico and the United States. Whiteford is involved in a second project in the Mexicali Valley, one that focuses on water security.

O. MSU gender researcher Diane Ruonavaara discusses participatory bean varietal selection with Ecuadorian researcher Cristian Subía and Edmundo Mendez, president of the village agricultural research committee, in Mr. Mendez's bean field in La Concepción, Ecuador. Ruonavaara was there in May 2004 as part of the Bean/Cowpea Collaborative Research Support Program (CRSP) team. MSU has served as the lead institution for the Bean/Cowpea CRSP, a USAID-funded program, since its inception in 1980. The current CRSP grant involves a partnership between twelve U.S. land-grant universities and a number of agricultural research institutions in Africa and Latin America. The mission of the Bean/Cowpea CRSP is to overcome malnutrition, stimulate economic growth, promote environmental stewardship, and improve the well-being of poor people, especially women, by generating technologies and knowledge that enhance the production, commercialization, and utilization of beans and cowpeas. The photograph was taken by Scott Swinton, Agricultural Economics.

P. Michael Kron, Medicine, is shown examining a patient at a clinic in Zapallo Grande, a rural jungle community in northwest Ecuador populated predominantly by Ecuadorians of African descent. He led a group of medical students from MSU and other universities participating in MSU's summer 1999 Primary Health Care in Ecuador study abroad program. The program combined academic work with clinical experience as it provided medical services to underserved communities. The photograph was taken by Payel Gupta, one of the MSU participants. Looking on are participants Natalia Lvoff from Northwestern University (*left*) and Johnny Leung from MSU (*right*).

Q. Students in the Environment and Land Use study abroad program study Mayan history as it relates to present-day social structure in southern Mexico. This photograph was taken in December 2000 on a visit to the archeological site of Chichén Itzá in the northern part of the Yucatán Peninsula.

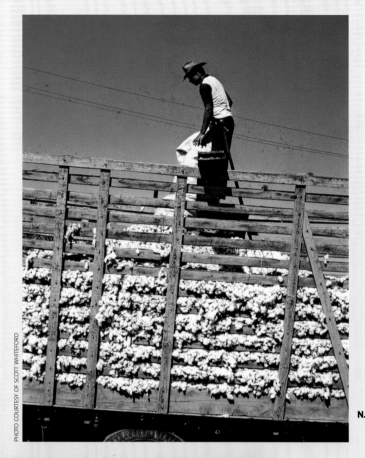

PHOTO COURTESY OF SCOTT WHITEFORD

N.

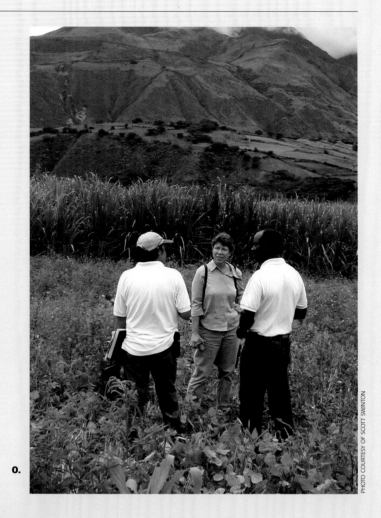

PHOTO COURTESY OF SCOTT SWINTON

O.

P.

Q.

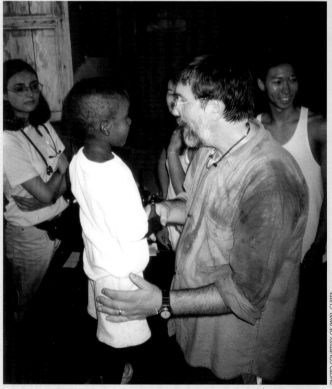

PHOTO COURTESY OF PAYEL GUPTA

PHOTO COURTESY OF H. PAUL ROBERTS

PHOTO COURTESY OF SERGIO FRANCO

R.

PHOTO COURTESY OF SOAR CONSORTIUM

S.

T.

U.

PHOTO COURTESY OF TED LOPUSHINSKY

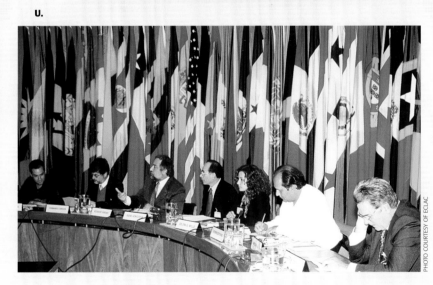

PHOTO COURTESY OF ECLAC

R. The Southern Astrophysical Research (SOAR) Telescope sits at 9,000 feet elevation in the Andes Mountains of Chile. Although Chile offers some of the world's best observing conditions, including a very high percentage of clear weather, occasional snow storms produce spectacular results, as can be seen here. MSU is a partner in the international consortium that built and operates SOAR; the other members include Brazil, the National Optical Astronomy Observatory, and the University of North Carolina at Chapel Hill.

S. The SOAR Telescope, shown here inside its protective dome, collects light with a concave primary mirror that is thirteen feet in diameter. The light is reflected upwards in a converging beam to a smaller mirror at the top of the telescope, then back down again to a still smaller mirror in the center of the primary mirror, and finally off to one of several instruments around the periphery of the telescope. MSU astronomers use SOAR and its suite of highly sensitive instruments to analyze the light from stars and galaxies throughout the universe, in order to learn about the structure and evolutionary history of the cosmos.

T. Students in the summer 1992 Natural Science in the Canadian Rockies study abroad program are joined by big-horned sheep as they take a lunch break during a day hike. Their destination was a peak where a fire watchtower and warden's cabin once stood. The photograph was taken by Ted Lopushinsky, now retired from Integrative Studies in General Science, who has been one of the program's leaders over its nearly thirty years of existence. Students learn geology and ecology while hiking and camping for twenty-five days in the Banff, Jasper, Yoho, Kootenay, and Mt. Assiniboine areas of the Canadian Rocky Mountain Parks system.

U. In late September 2001 MSU and the U.N. Economic Commission on Latin America and the Caribbean (ECLAC) cosponsored a conference in Santiago, Chile, on Social Capital and Poverty Reduction in Latin America and the Caribbean: Toward a New Paradigm. Well over three hundred people, including researchers and government representatives from seventeen countries, attended the conference. The MSU delegation of nearly twenty individuals was headed by President Peter McPherson and included ISP Dean John Hudzik and a number of faculty members involved in MSU's Social Capital Initiative, including co-directors Lindon Robison and Marcelo Siles. MSU participants pictured in this photograph are Manuel Chávez (*far left*), René Hinojosa (*fourth from left*), and Celina Wille (*fifth from left*).

V. Canadian Prime Minister Jean Chrétien (*left*) and his wife, Aline, stroll across the MSU campus with MSU President Peter McPherson. Chrétien was on campus for May 1999 graduation ceremonies. He addressed the advanced degree candidates and received an honorary Doctor of Laws degree, his first honorary degree from a U.S. institution. McPherson has been involved in issues related to the Canada–U.S. Free Trade Agreement.

W. President John Hannah (*right*), looks out from the doorway of a structure at Ft. Churchill in Manitoba, Canada. This archival photograph was taken during a visit he made in March 1954. For a number of years during his presidency Hannah was chairman of the United States Section of the U.S.–Canada Permanent Joint Board on Defense.

X. Taking the traditional freshman seminar concept a step further, MSU has created a Freshman Seminars Abroad program to provide a unique opportunity for incoming students to gain international experience, to develop an appreciation of the knowledge and skills required to become successful players in a global economy, and to get an initial taste of the study abroad experience. The first Freshman Seminar Abroad took place in Quebec City, Canada, from 24 July to 4 August 2003. Thirty-five freshman, including those pictured here, were exposed to college-level academic expectations while exploring a culturally, politically, and historically fascinating region close to home. Two other 2003–4 groups went to Monterrey, Mexico, and to Dublin and Galway, Ireland.

V.

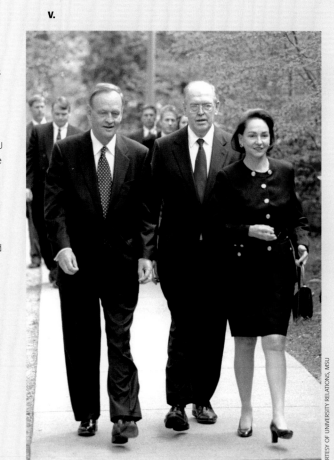

PHOTO COURTESY OF UNIVERSITY RELATIONS, MSU

W.

PHOTO COURTESY OF MICHIGAN STATE UNIVERSITY ARCHIVES AND HISTORICAL COLLECTIONS

X.

PHOTO COURTESY OF PHILIP HANDRICK

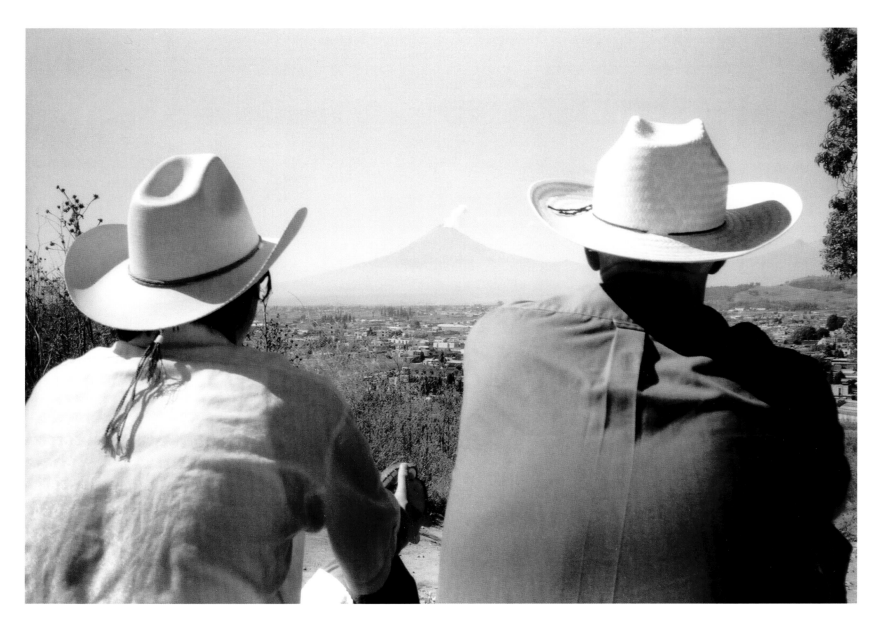

"Buena Vista" is one of those pictures you just sort of stumble upon, two folks talking about life and nature taking its course. A recipe for a great image, from a great day, in a place that I really love.

"Buena Vista (The Mountain One)"
2000 Student First Place
Jonathan Schulz, *Cocotitlán, Mexico, 2000*

This photo was taken on a visit to San Cristobal de las Casas, Chiapas, Mexico. It is a photo of a family from the local indigenous group. The curious and eager children and their mother sell their handmade crafts on the streets and were eager to pose and smile for my pictures in exchange for some cookies and their own Polaroid to keep.

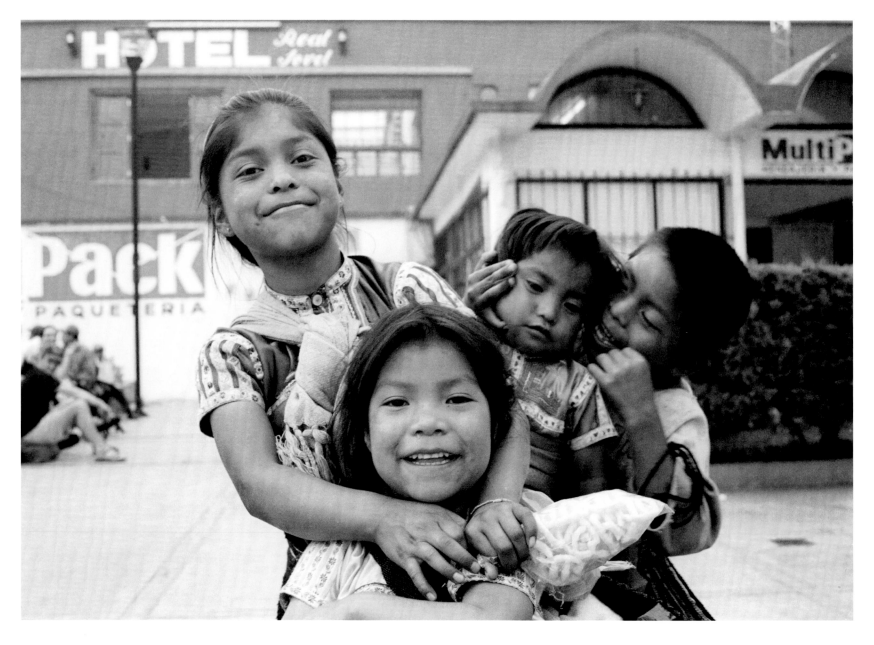

"La Familia Unida"
2003 Student Honorable Mention
Leslie Richards, *Mexico, 2003*

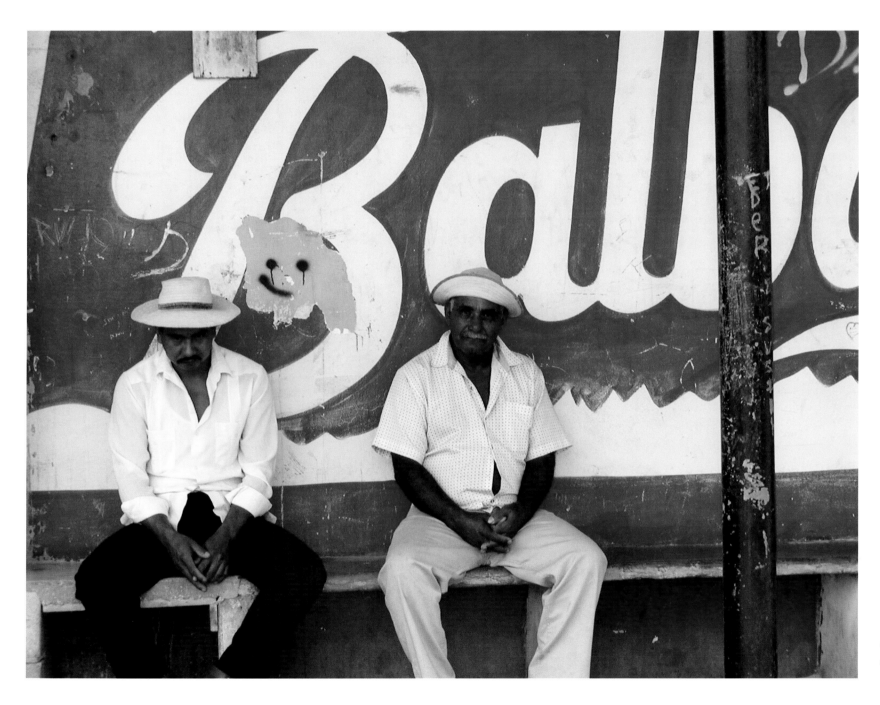

Waiting for a bus? Passing the time of day? These men sat outside a store in the shade of an overhang in the mountain town of El Copé, Panama. Wearing traditional Panama hats, typically with brim turned up, they keep cool on a hot day.

"Panama Smile"
2003 Faculty/Staff First Place
Philip Durst, *Panama, 2003*

There is an indoor vegetable market in Chichi-
castenango with a balcony surrounding the square.
I was on the balcony looking through my lens when
the little girl in the center of the photo turned her
head and looked right at me. I snapped the shutter
before she turned here head and captured "Market
Child."

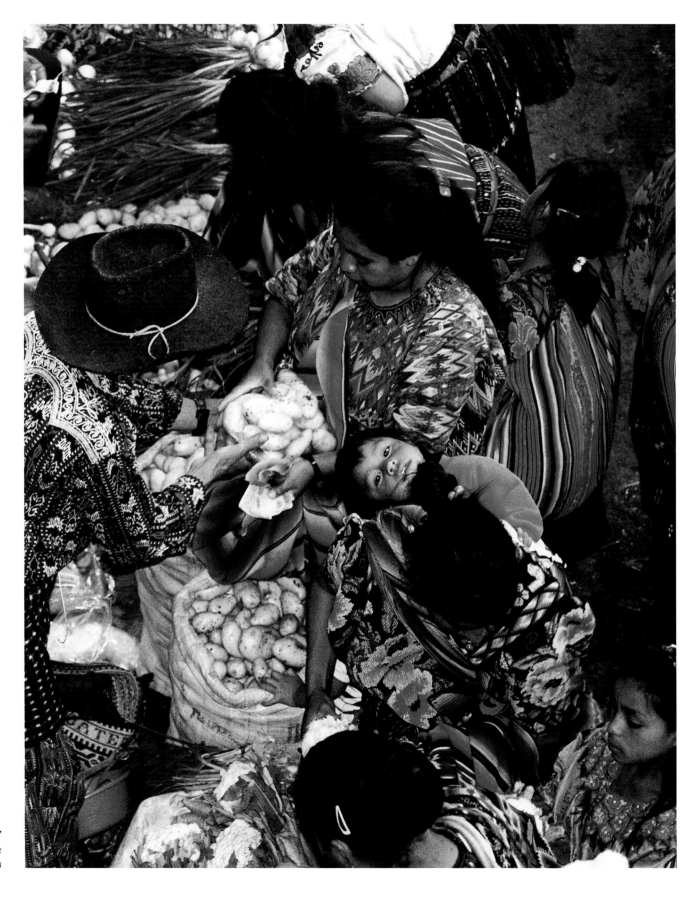

"Market Child"
1999 Alumni First Place
Richard McDonald, *Chichicastenango, Guatemala, 1999*

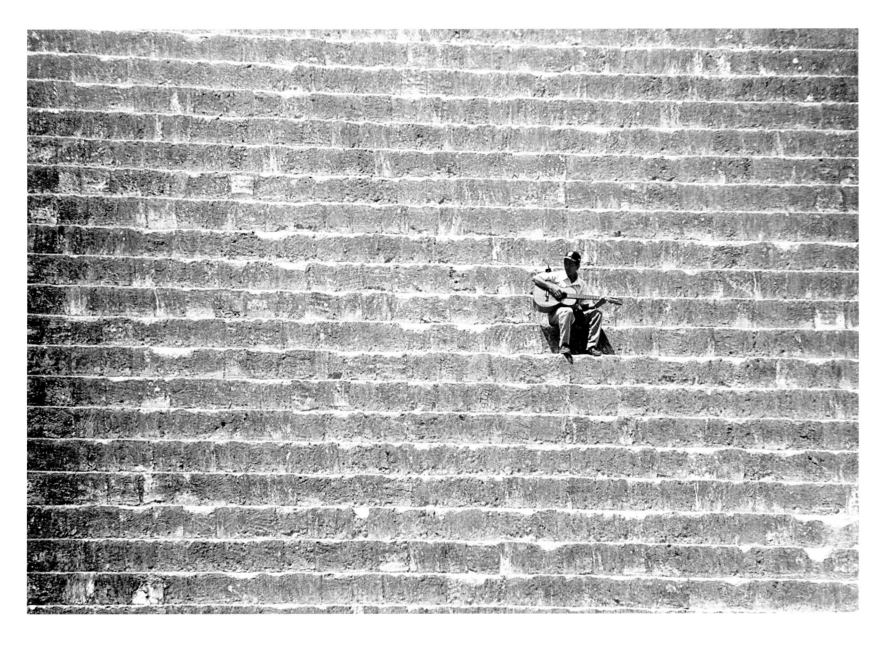

While walking through Tikal National Park in Guatemala, with one of the largest concentrations of Mayan ruins in Central America, I shot this man singing on the steps of the Temple of the Jaguar, the centerpiece of the ruins.

"La Música de la Maya"
2001 Student Honorable Mention
Rob Gorski, *Guatemala, 2000*

I had traveled to Haiti with a nonprofit group to build chairs for a Haitian school. On the last day, having built about fifty or so wooden chairs, we decided to take a rest before heading back to the guest house where we were staying. At that point, James, the child in the picture, noticed my camera, and we started to play a game of hide-and-go-seek. . . . In James's eyes I still see Haiti and its isolation, but also its eager will to be accepted.

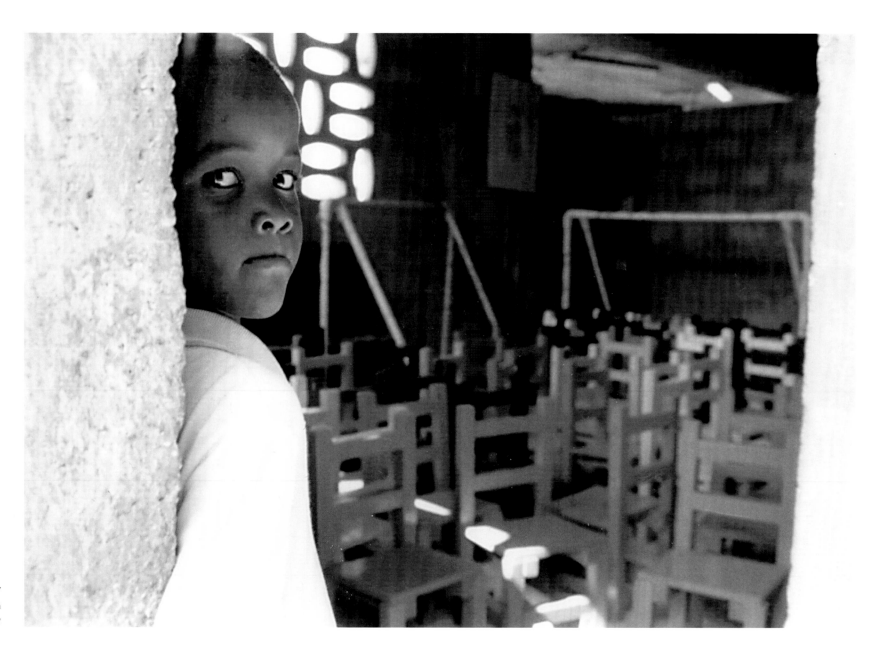

"Hide and Go Seek"
2001 Student Honorable Mention
Kyle Martin, *Haiti, 2001*

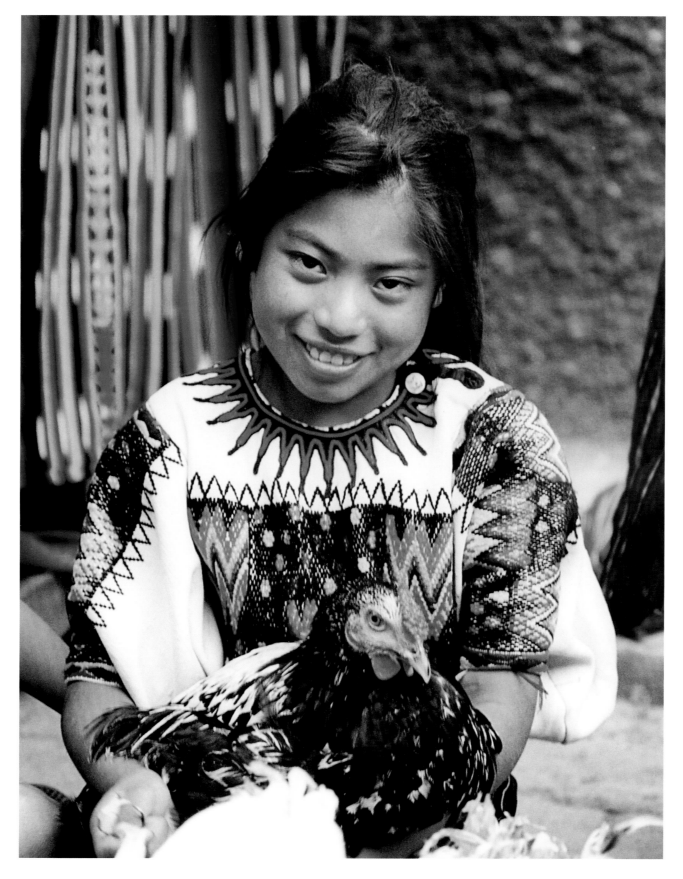

On Thursday and Sunday, Chichicastenango hosts a market where locals buy and sell their wares. The girl in the photo was sitting on the ground and petting the chicken in her lap, smiling the whole time. . . . I have a feeling the chicken might have been sold by the end of the day, but she seemed very happy to have a "pet" for at least that moment.

"Pet Happiness"
1999 Alumni Honorable Mention
Richard McDonald, *Chichicastenango, Guatemala, 1999*

"Ecological Study of Costa Rican Rainforest" was taken in the Barra del Colorado Wildlife Refuge. For several hours we hiked and canoed through this remote tangle of jungle, mangroves, lagoons, and rivers learning about the fascinating and rich biodiversity of this northeastern coastal area of Costa Rica.

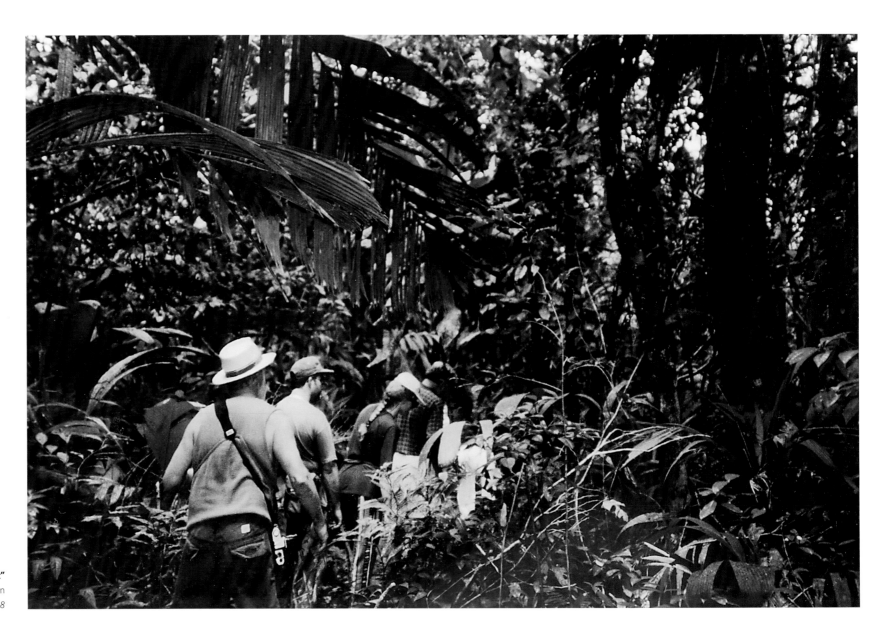

"Ecological Study of Costa Rican Rain Forest"
1999 Faculty/Staff Honorable Mention
Andrea Funkhouser, *Costa Rica, 1998*

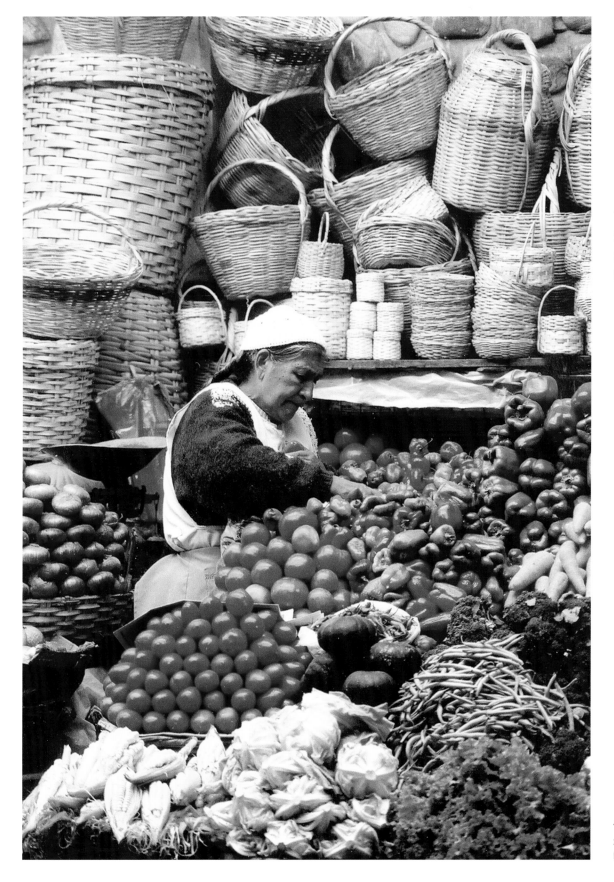

The photo was taken in the morning in the market in Sucre as people were going about their business. Sucre is a beautiful town in the mining areas of Bolivia.

"Cestas y Veduras"
2000 Student Honorable Mention
Bronwyn Irwin, *Sucre, Bolivia, 1999*

The picture was taken in early morning while at the base of the Ecuadorian volcano named Pinchincha. It was shot looking out at the foothills and farms surrounding the mountain.

"El Camino"
2001 Student Honorable Mention
Jordon Harris, *Ecuador, 2001*

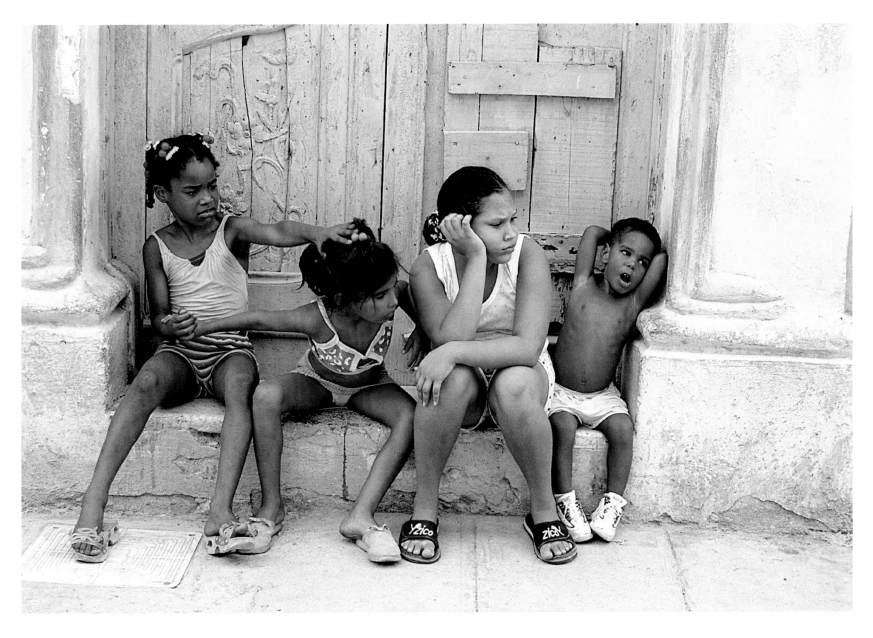

The children in this photo were very entrepreneurial, soliciting dollars for getting their photo taken. Someone in the group of tourists denied them their pay, and their dejection and anger came out in the photo. . . . As I look back on most of my photos from Kenya, Tanzania, Peru, Honduras, and Cuba, the running theme is the beauty and consistency of children being children no matter the latitude.

"School's Out in Havana"
2002 Student Honorable Mention
Heather Costello, *Cuba, 2001*

This picture was taken while descending a steep mountain pass near Mt. Quilotoa in rural Ecuador. The sheep and the herders were on their way up.

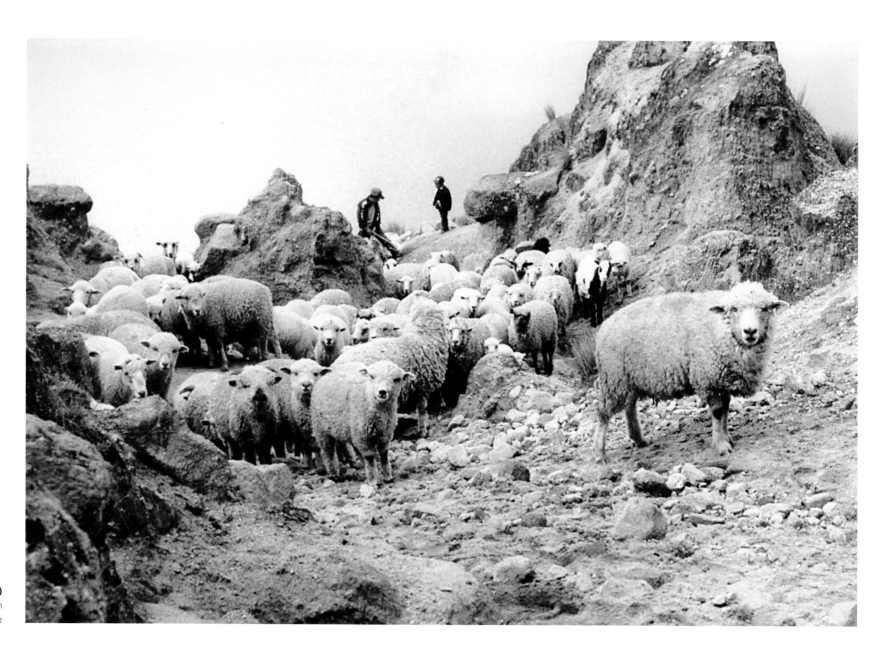

"Los Carneros" (The Sheep)
2001 Student Honorable Mention
Jordon Harris, *Ecuador, 2001*

On an afternoon island walk with a local guide . . . the sun was breaking through the palm trees enhancing the already beautiful colors in the scene. The houses begged to be photographed for the world to see.

"Island Houses"
2003 Faculty/Staff Honorable Mention
Michele Madison, *Dominican Republic, 2001*

The Amazon River in Brazil floods its floodplain every year. People living in the region have learned to live with this annual event, raising their houses to be just above the highest river stage.

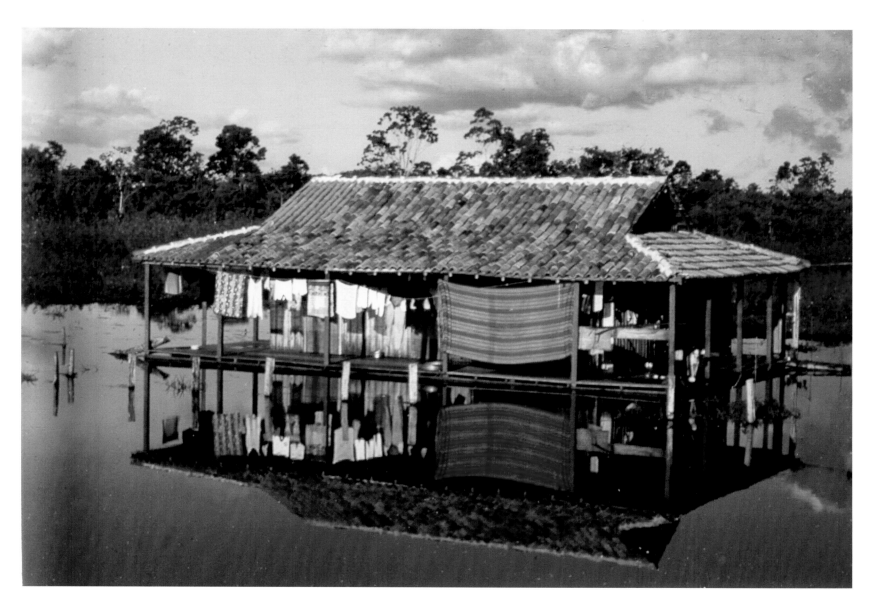

"Living with the Flood"
2000 Faculty/Staff Third Place
Antoinette WinklerPrins, *Amazon River flood plain, Brazil, 1996*

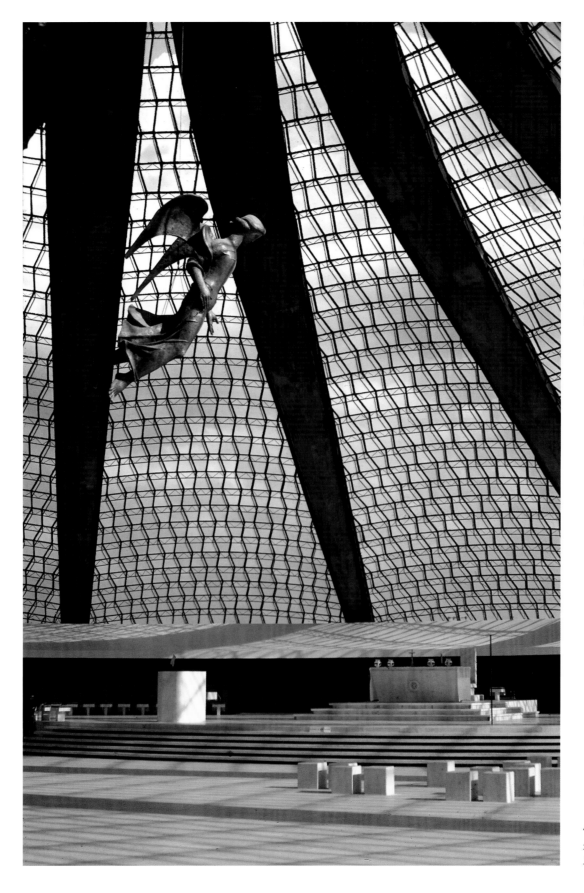

In the 1960s and 1970s I was involved in a series of development projects in Brazil, funded by various agencies. Brasilia, an imaginative city, created from scratch in the hinterlands of Brazil, embodied the country's modern energy. This interior shot of the National Cathedral captures that spirit.

"Interior, National Cathedral"
2000 Faculty/Staff First Place
John M. Hunter, *Brasilia, Brazil, 1970*

This photo was taken after traveling over 100 km in a four-wheel-drive vehicle over bad roads to a remote river in southern Brazil where we were sampling aquatic insects for a water quality survey. We had to go through this property, and the family was looking at us from their house window and wondering what in the world we were doing sampling in a river near their farm.

"Brazilian Farm Family"
2003 Faculty/Staff Honorable Mention
Richard Merritt, *Brazil, 2003*

The "Mañanera" photo was taken very early in the morning on the main plaza in Cuzco. It appeared that the woman was headed for some early morning shopping at the market.

"La Mañanera"
2002 Alumni Second Place
Linda Roberts, *Peru, 2002*

As the pictures in this collection demonstrate, MSU's past, present, and future are intertwined with those of Asia and Oceania. The University's ties with the East and Antipodes, in fact, predate the earliest of the archived photographs included herein.

In 1884 a Japanese student, Michitaro Tsuda, became one of the first overseas students to graduate from what was then known as the State Agricultural College. Enrollment records indicate that he was probably not breaking new ground, but following the path taken by others who traveled thousands of miles by ship, rail, and horse carriage, and who finally arrived on foot and encountered a world new to them in East Lansing, Michigan.

As might be expected, MSU's Asia connection has changed dramatically in the nearly 150 years since the arrival of Michitaro Tsuda and his predecessors. The early archival photographs in this collection suggest that first contacts were largely one-sided. Students from Asia and Oceania, such as those posed in their starched collars and wool suits in the Cosmopolitan Club photographs, came to East Lansing to learn, but few from Michigan's agricultural college sought wisdom in supposedly less enlightened lands across the Pacific. This should come as no surprise given the economic and political perceptions of the day that were based on the assumption that the United States was the world's emerging power, a beacon of enlightenment to darker, less-developed places. When the "torch of civilization" was carried abroad from the late nineteenth into the twentieth century, it was usually held high by missionaries and businesspeople promoting their own vision of salvation and successful commercial culture. They typically went to preach and to teach, not to learn. This attitude probably prevailed at MSU as it did at other colleges and universities across the nation and in other metropolitan places throughout the Western world.

The shape and direction of MSU's international engagement has changed dramatically since John Hannah became president in 1941, and especially since the end of World War II. During the 1950s and 1960s Hannah transformed Michigan State College into Michigan State University, a transformation that changed the institution from a rather inward-looking land-grant college to an internationally focused "megaversity." The land-grant idea took on an international dimension, which was manifested in the export of aid, advice, and development. Snapshots of this process can be seen in photographs that document the work of MSU representatives in Japan, Pakistan, and Vietnam. This postwar shift substantially changed the formerly one-way nature of MSU's international engagement. As Milton Muelder, Iwao Ishino, Ralph Smuckler, and other participants in these major projects attest, the initial goal may have been to teach or impart ideas, but the actual process turned out to be a profound learning experience that touched everyone involved.

The learning process was at times painful. One motor driving MSU's rise to megaversity status was a massive increase in federal and other external funding supplied for specific projects, some involving the formulation and implementation of Cold War policies. The Vietnam project, the merits and demerits of which are still debated, is one dramatic example of the perils inherent in deep engagement in international affairs. But in-depth involvement can also yield lasting benefits. This can be seen in the successful MSU projects leading to the creation and growth of the University of the Ryukyus in Okinawa, Japan, during the 1950s and 1960s. It is also evident in the establishment of academic ties with the People's Republic of China in the 1970s and 1980s, and in a wide range of educational, environmental, and scientific ventures ongoing today from Australia to Vietnam.

The present degree of integration of the Asian region and MSU is matched by the diversity of linkages. Today MSU students, participants in one of the largest study abroad programs in the United States, travel to countries throughout Asia and Oceania to experience and learn. They can be found alongside MSU faculty members learning to shear sheep in Australia, studying Japanese language in the Ryukyus, and working to conserve panda habitats in China. As is evident in this photographic collection, international learning at MSU long ago ceased to be unidirectional. This healthy development is not totally unexpected given the transformations that have occurred at home as well as abroad. In fact, the university itself has become something of a vast mixing bowl of different cultures and peoples—not a melting pot in which distinctive qualities are dissolved into a bland uniformity, but a place where

difference is appreciated, accepted, and respected. The transformation owes much to the power of ideas to change minds, and it also reflects demographic changes apparent in the growing ethnic diversity of Michigan's population and the contributions of multicultural Asian Americans among our students and faculty.

Today, MSU continues to recognize the importance of the Asian region by creating new programs for the teaching of Asia-related courses in the liberal arts and social sciences. This includes a superb language curriculum that offers students opportunities to learn Korean, Tagalog, Vietnamese, Hindi, Japanese, and Chinese. Since 2000 the U.S. Department of Education has rec-ognized the breadth and depth of MSU's commitment to Asia by designating the university's Asian Studies Center, the only all-Asia center in the United States, a National Resource Center for education about Asia. Although the photographs in this book illustrate MSU's international studies and other programs at work abroad, it is important to remember that the beliefs and attitudes that have prompted commitment to such efforts are in many ways homegrown. The many ties that bind MSU and Asia-Oceania remind us that the East and the Antipodes are no longer exotic, faraway places, and that our engagement with the region's peoples and cultures has become an inextricable part of the MSU experience at home and abroad.

MICHAEL LEWIS
Director, Asian Studies Center

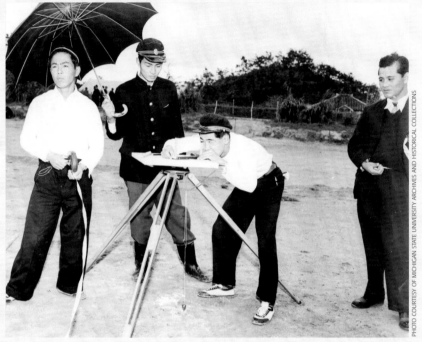

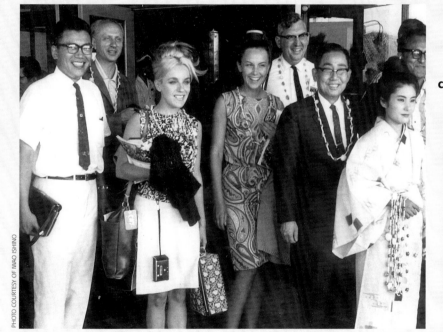

A. Glen Taggart, the founding dean of the Office of International Programs, sits on a piece of farm equipment during a visit to a Taiwanese agricultural facility in the early 1960s. Taggart led the office from its 1956 inception until 1968, shaping the organization and setting the course largely in place to this day.

MSU's College of Agriculture was the driving force behind the development of colleges of agriculture at the National Taiwan University and Chun Hsing University between 1960 and 1964. The man wearing a tie is probably Karl Wright, Agricultural Economics, who was chief of party for the Taiwan project.

B. The United States was an occupying power in Japan and elsewhere in the South Pacific, including the Ryukyus Islands, for a period after the end of World War II. In 1950 Milton Muelder, then chair of Political Science and Public Administration, was asked to develop the original proposal for a collaborative partnership that would result in the creation of a land-grant university on the main island, Okinawa. The following year Michigan State sent its first contingent of five faculty members to the newly created University of the Ryukyus (UR). More than forty additional Michigan State faculty members held positions there between 1951 and 1968, when the formal partnership ended.

In this photograph from the 1950s, members of Future Farmers of Okinawa conduct a field project during the annual meeting of their organization.

C. One aspect of the strong relationship between Michigan State and UR was the Michigan Ryukyus Exchange Program (MREP). Iwao Ishino (*left*), now professor emeritus of Anthropology, had recently joined the Michigan State faculty when he was assigned to be chief of party of the Ryukyus project. In this photograph, taken in the mid 1960s, he is standing with two female students who participated in the exchange and UR President Shimabukuro, along with other MREP staff members and a local woman in traditional attire.

D. A nine-person delegation from Michigan State University traveled to Okinawa, Japan, in May 2000 on behalf of MSU President Peter McPherson to participate in the fiftieth anniversary of the founding of the University of the Ryukyus. Shovels in hand, Milton Muelder, MSU vice president emeritus for Research Development (*left*); Cecil Mackey, former MSU president (*center*), and UR President Moshin Morita (*right*) plant the "tree of friendship" presented by MSU to commemorate the occasion.

E. / F. One of MSU's more controversial international involvements was the Vietnam Police and Public Administration project, the largest of MSU's early technical assistance programs, which operated between 1955 and 1962. Led by Wesley Fishel, Political Science and Public Administration, the project was funded by U.S. government assistance programs to lend support to the newly formed government of South Vietnam. With a staff of around thirty individuals, it focused on the areas of public administration, economics, public relations, and police training.

These two photographs were supplied by University Archives and Historical Collections. The first, taken at an unspecified location in Vietnam, bears the caption, "Another bridge built (through community development)." The second depicts a group of Vietnamese scholars arriving at the Lansing Airport on 3 January 1959 to attend classes at MSU. The man on the right is Stanley Sheinbaum, Economics, the on-campus coordinator of the project.

G. In 1957 Michigan State became involved in a major project in Pakistan, supplying technical assistance in the development of two rural development academies. One was in Comilla, East Pakistan (now Bangladesh), and the other was in Peshawar, West Pakistan (now simply Pakistan). The mission of these academies was to provide university-level training for rural development leaders. Most of the Pakistani faculty came to Michigan State for preparation, and when the academies began offering classes in 1959, six Michigan State faculty members joined them. The project director was Richard Niehoff (*left*), Administration and Higher Education, shown here in the Comilla office of Akhter Hameed Khan (*right*), the first director of the Academy for Rural Development.

H. William C. Taylor, MSU professor of engineering and former dean of the MSU College of Engineering, was in Pakistan in January 1995 for the dedication of the National Highway Institute, a division of the National University of Science and Technology (NUST), which he helped to establish. In this photograph, Taylor (*right*) speaks with Prime Minister Benazir Bhutto and NUST Rector Shujaat Hussain. In 1999 Taylor was awarded the Sitara-i-Imtiaz, the Star of Recognition, by the president of Pakistan.

E.

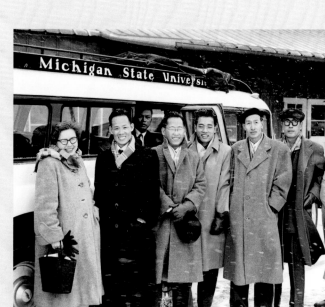

F.

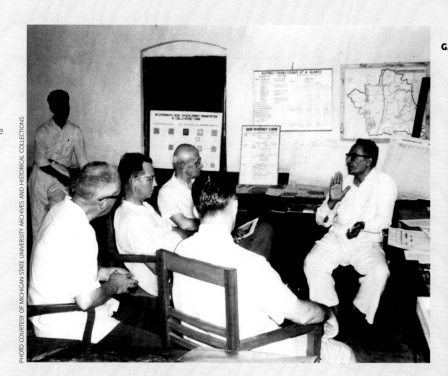

G.

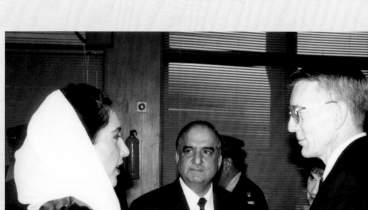

H.

I. MSU President John DiBiaggio and President Susumu Takeda of Mie University, Japan, formally sign a renewal of the 1961 linkage agreement between their respective institutions in 1986. During DiBiaggio's presidency several major international agricultural projects were begun, including some related to food security and agricultural biotechnology. Important international thematic units, such as the Institute of International Health, the International Business Center, and the Center for International Business Education and Research, were also established at MSU during the DiBiaggio years.

J. In 1980 MSU sent a sizeable contingent of faculty and administrators to China to pursue academic linkages between MSU and a number of Chinese universities. This photograph of MSU and Chinese university colleagues was taken at the University of Chengdu, Sichuan Province. The mission resulted in a number of faculty and student exchanges as well as academic and research relationships between several MSU units and their counterparts at the Chinese institutions. Among those participating in the delegation were (*seated*) Dean Alan Hollingsworth, College of Arts and Letters (*left*); Harold Riley, chair of the Department of Agricultural Economics (*second from left*); Warren Cohen, director of the Asian Studies Center (*fourth from left*) with his wife, Janice; ISP Dean Ralph Smuckler, who headed the mission (*sixth from left*); Dean James Anderson, College of Agriculture and Natural Resources (*eighth from left*); Sylvan Wittwer, director of MSU's Agricultural Experiment Station (*ninth from left*); Bernard Gallin, chair of the Department of Anthropology (*tenth from left*); and William Tai, Botany and Plant Biology, who was the "in-country" coordinator of the trip (*far right*).

K. MSU President Clifton Wharton greets international students from Thailand as they arrive for registration in 1970. Wharton was a well-respected international development expert prior to assuming the MSU presidency, having worked at the Agricultural Development Council for thirteen years before to coming to MSU. While president, he served as the initial chairperson of USAID's Board on Food and Agricultural Development. At one point during the Clinton administration Wharton served as deputy secretary of state.

L. In Pakistan, community schools represent a major opportunity for girls, since they provide a "safe" place for education (the village) and teachers are usually female. These schools are co-funded by villages and the Provincial Office of Education. In January 1996 Christopher Wheeler, Teacher Education, visited a number of these schools in the northern part of the country as a member of a World Bank assessment team. Although the winter weather there is typically severe, on this day it was warm enough for several of the students in the community school to venture outside with their textbooks, where Wheeler snapped this photograph.

J.

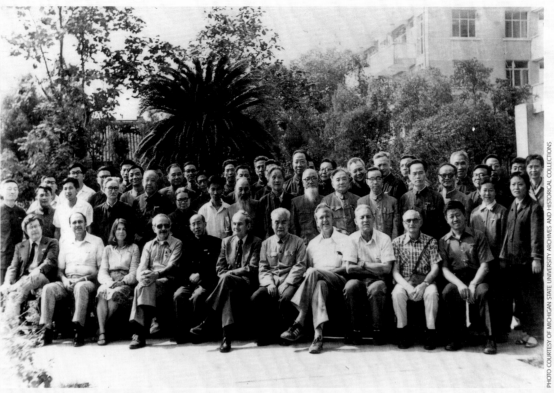

I.

K.

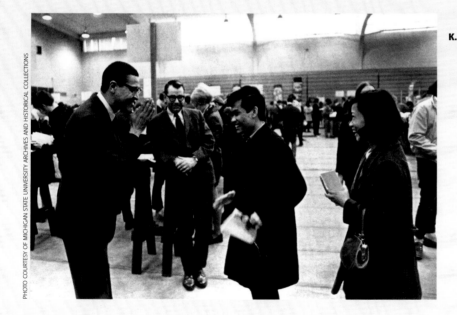

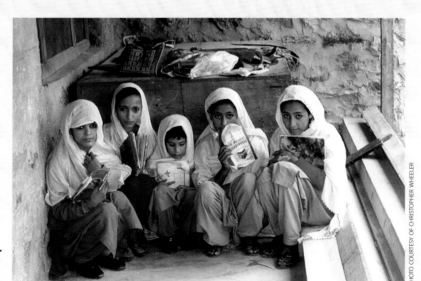

L.

M. Vietnamese students work in a school organic garden, one of many small-scale projects underway as MSU works with Cantho University to improve household income in very poor rural areas of the Mekong Delta of Vietnam. A key part of the project, begun in 2001, is to link school reform to community development in new and innovative ways. The "demonstration-direct-diffusion" approach is used where schools initiate projects, work with parents to begin them at home, and then diffuse them through community organizations. All activities are carefully linked to the curriculum to promote student learning. This photograph and the next one were taken by Christopher Wheeler, Teacher Education, who coordinates MSU's multidisciplinary involvement in the project.

N. William Hug, a visiting assistant professor of higher education at MSU when the photograph was taken, and Tran Tuong Thuy, a Vietnamese project field worker, are shown crossing a canal to visit community development projects at Can Tho University's Hoa An Research Station. Such projects include not only organic gardens, but also "integrated pest management" rice cultivation projects, animal husbandry, aquaculture, and integrated farming systems models.

O. International Studies and Programs Dean John Hudzik and eight MSU faculty colleagues traveled to Cantho University (CTU) in Vietnam's Mekong Delta region for five days in December 2003. Their trip to explore possibilities for expanding mutual cooperation between MSU and CTU was at the invitation of CTU Rector Le Quang Minh. While in Cantho, the MSU group was invited to visit CATACO, a local seafood processing facility that produces food products for export. They observed all the stages of seafood processing and packaging and received an overview of the industry's state-of-the-art product safety practices. In this picture, Syed Hashsham, Civil and Environmental Engineering; James Tiedje, Crop and Soil Sciences; Kim Scribner, Fisheries and Wildlife; and Susan Conrad, Cellular and Molecular Biology, prepare for the tour.

P. In October 1998, then-Provost Lou Anna Simon undertook a four-country Asian tour to meet with MSU international partners and international alumni. She was accompanied by several other MSU administrators as she visited sites in Japan, Thailand, Vietnam, and South Korea. In this photograph, members of the MSU Alumni Club of Korea stand behind Simon (*seated, center*), ISP Dean John Hudzik (*seated, fourth from left*), Gill-Chin Lim, professor of geography (*seated, far left*), and Michael Miller, director of MSU's Visiting International Professional Program (*seated, far right*).

M.

PHOTO COURTESY OF CHRISTOPHER WHEELER

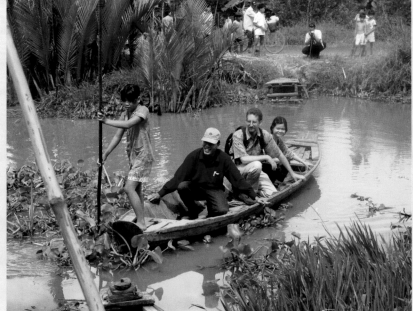

N.

PHOTO COURTESY OF CHRISTOPHER WHEELER

O.

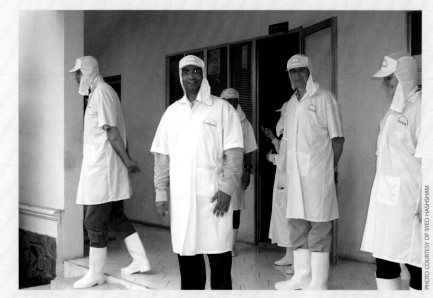

PHOTO COURTESY OF SYED HASHSHAM

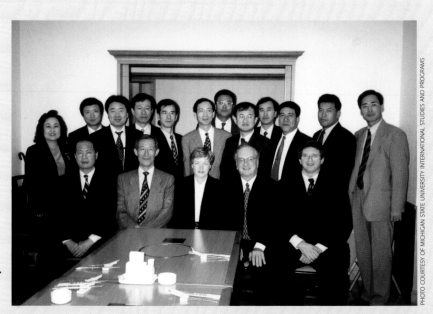

P.

PHOTO COURTESY OF MICHIGAN STATE UNIVERSITY INTERNATIONAL STUDIES AND PROGRAMS

Q.

R.

S.

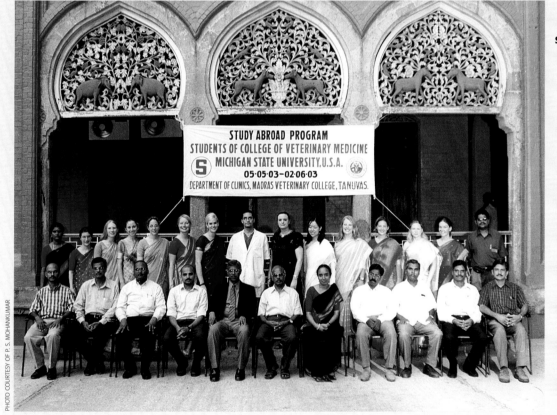

STUDY ABROAD PROGRAM
STUDENTS OF COLLEGE OF VETERINARY MEDICINE
S MICHIGAN STATE UNIVERSITY, U.S.A.
05·05·03~02·06·03
DEPARTMENT OF CLINICS, MADRAS VETERINARY COLLEGE, TANUVAS.

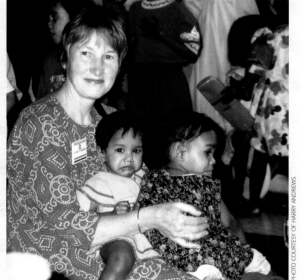

T.

Q. Building on the success of the Michigan Political Leadership Program (MPLP), faculty in the College of Social Science have offered political leadership workshops to international constituencies. In 1998 such a workshop was offered in Seoul, South Korea. In this photograph, Philip Smith, Labor and Industrial Relations and associate dean in Social Science, addresses the audience as Lynn Jondahl, co-director of MPLP, observes. The audience consisted primarily of local political and academic leaders, as well as individuals aspiring to political office. The South Korean organizers hoped to develop their own political leadership workshops in the future.

R. In the summer of 2002 MSU marketing major Rachel Ciccone was in Sydney, Australia, on a study abroad internship program administered by MSU for the Committee on Institutional Cooperation, a consortium of Midwestern universities that includes MSU. In July she and other students visited the Aboriginal Historical and Cultural Center in Cairns. In this photograph they watch Aborigines build a fire. This photograph won first place in the People category of the 2002 Spartans Abroad photograph contest sponsored by the Office of Study Abroad.

S. In May 2003 the first set of Veterinary medicine students traveled to India to participate in the newly organized study abroad program at Madras Veterinary College, a component of Tamil Nadu Veterinary and Animal Sciences University (TANUVAS). The program provides the students exposure to tropical veterinary medicine and Indian culture. They work in the clinics for four weeks and visit various institutions associated with TANUVAS. They also visit centers of cultural importance during the weekends. From TANUVAS they travel to Mudumalai wildlife sanctuary, the second largest Asian elephant sanctuary in the world, where they spend two weeks working with the forest veterinary surgeon, learning about elephants and other wild animals in the sanctuary. This photograph was taken while still at TANUVAS. The program's co-leaders are Puliyar MohanKumar (*seated, fourth from left*) and Sheba MohanKumar (*seated, seventh from left*), both of the MSU Department of Pathobiology and Diagnostic Investigation.

T. In 1998 Mary Andrews, director of International Extension Programs, visited Mother Teresa's orphanage in Calcutta, India. In this photograph, taken by her husband, Harry Andrews, she is seated on the floor with two children on her lap. She reports being impressed by the sense of calm and order in the facility, in contrast to the chaos of the surrounding slums. In addition to her international extension activities in Michigan and around the world, Andrews leads a yearly study abroad program in New Delhi, India, that includes a six-week field placement internship experience for the students, typically with a non-governmental organization.

U. A visit to the Kuriong Sheep Station is always included in MSU's The People, Government, Justice System, and Public Policies of Australia, a study abroad program based at the University of New South Wales in Sydney and in the capital city of Canberra. This field trip, in contrast with that urban setting, gives participants a look at rural life and the importance of commodities to the Australian economy. This photograph and the next one were taken by John Hudzik, dean of International Studies and Programs and faculty leader of the yearly program.

V. During the Canberra portion of the program, students visit the Parliament Building as a part of their introduction to the Australian governmental system. They often witness "question time," where the Prime Minister fields questions from members of Parliament. In this photograph, they are shown in the House of Representatives chamber during a quieter moment.

W. On 17 October 1989 MSU alumnus Verghese Kurien received the 1989 World Food Prize at a ceremony at the Smithsonian Institution in Washington, D.C. Kurien, who earned a Master of Science degree in mechanical engineering from MSU in 1948, is credited with transforming the milk industry in his native India. Operation Flood, consisting of farmer-owned milk cooperatives, has improved milk production and distribution throughout the country, helping rural poor who produce milk and urban poor who consume it. This photograph, taken on World Food Day (the day before the ceremony), shows Kurien being congratulated by President George H. W. Bush at the White House.

X. The impact of human activity on the habitat of giant pandas in China's Sichuan Province is a major focus of research conducted by Jianguo (Jack) Liu, MSU Department of Fisheries and Wildlife, and colleagues. This photograph of pandas, taken at China's Center for Giant Panda Research and Conservation in 2002, includes (*left to right*) Sue Nichols, MSU University Relations; Hemin Zhang, director of the center; Liu; and Hongying Han, a staff member at the center. MSU has been expanding linkages with various Chinese universities.

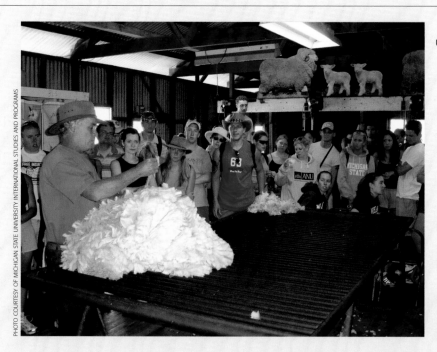

U.

V.

W.

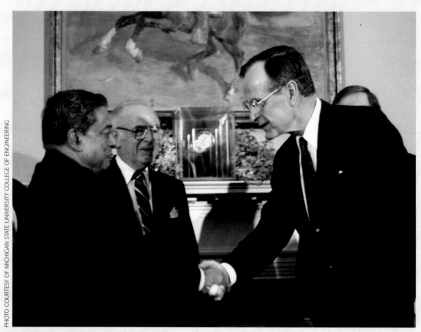

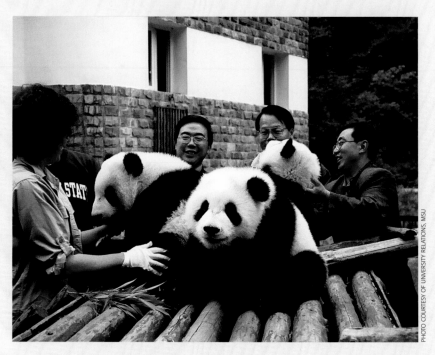

X.

Y. Students enrolled in the 2004 Summer Intensive Language Program at the Japan Center of Michigan Universities (JCMU) are introduced to the koto (a Japanese harp) by Minori Ukawa, a local instructor, during a weekly cultural demonstration on the JCMU campus in Hikone, Japan. Other interactive demonstrations, including such Japanese traditions as tea ceremony, flower arranging, calligraphy, and judo, are also offered. JCMU is the centerpiece of the strong sister-state relationship between the state of Michigan and Shiga Perfecture in Japan. Since its inception in 1989 JCMU has provided educational experiences for students from Michigan and elsewhere in the United States who wish to learn Japanese language and culture, as well as for Japanese students wishing to learn English. The JCMU campus is located on beautiful Lake Biwa, the largest freshwater lake in Japan. The program is administered on behalf of the consortium of Michigan public universities through MSU's Office of International Studies and Programs.

Z. In October 2003 ten public school teachers from the state of Michigan, along with several faculty members from MSU, traveled to Nepal on a Fulbright-Hays Group Projects Abroad study tour. The theme of the visit was Understanding the Rivers, Environments and Cultures, and the primary purpose was to enable the teachers to incorporate firsthand experience of non-Western culture into their curricula. In addition to experiencing the Nepali culture through lectures and brief home stays, they participated in water quality testing activities and learned about the Nepali school system, particularly environmental education. In this photograph, taken by Jay Rodman, International Studies and Programs, students from a Pokhara-area school examine organisms in a water sample taken from the Seti River. Fred Stehr, Entomology, looks on.

PHOTO COURTESY OF JAPAN CENTER FOR MICHIGAN UNIVERSITIES

Y.

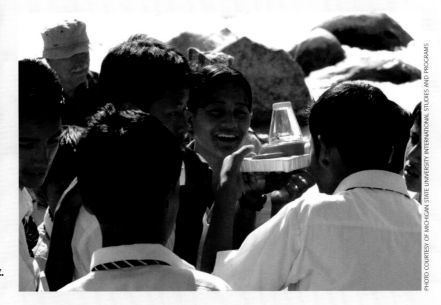

Z.

PHOTO COURTESY OF MICHIGAN STATE UNIVERSITY INTERNATIONAL STUDIES AND PROGRAMS

One of the things that impressed me the most about Hong Kong—I guess like all big cities—was the action, the crowds, and the intensity of everything. I was walking by an empty soccer stadium and noticed him, but it was so dramatically different from the action on the streets. The colors of his bag matched so perfectly with his surroundings that I wanted to capture the moment.

"Reading the Paper"
2001 Faculty/Staff Honorable Mention
Thomas Stanulis, *China, 1998*

This photo was taken near Kagbeni, a small village north of the Annapurna Himalayan range. The area is arid and desolate, making existence at a day-to-day level very difficult. Walking along the trail, I came upon this group of affable women tending this fragile earthen place. Their smiles made it seem like an oasis of the spirit.

"Planting, Laughing, Smiling"
1999 Student First Place
Matthew Geisler, *Kagbeni, Nepal, 1999*

I was visiting a city in southwestern China that was full of outdoor markets with hanging meat and people selling live chickens and snakes right on the streets. As I was walking down the street, I saw someone getting their hair cut outside on the sidewalk. The bright blue, yellow, and red colors really struck me in contrast to the monotone surroundings in this industrial city.

"Haircut"
2001 Faculty/Staff Second Place
Thomas Stanulis, *China, 1998*

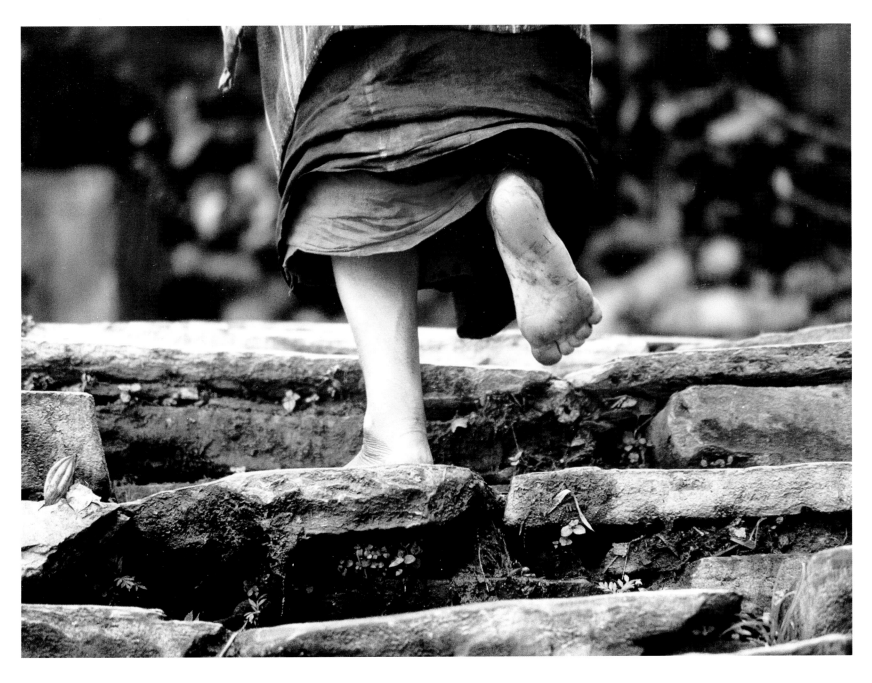

I captured this image of an older Nepali woman climbing from a side alley to the main road in Dunche. Her day's chores were lashed around her forehead, her clothes were faded and beautiful, and her black hair was wrapped so as not to interfere with her effort.

"Woman's Work"
2000 Student Second Place
Robert Gorski, *Dhunche, Nepal, 2000*

In a village near Sakon Nakhon, in northeast Thailand, an elderly Bruu man attends rice thrashing where a mechanical thrasher processes the crop. Set up on the edge of the paddies, this thrasher was in contrast to the more common hand thrashing of rice bundles that occurred throughout the village.

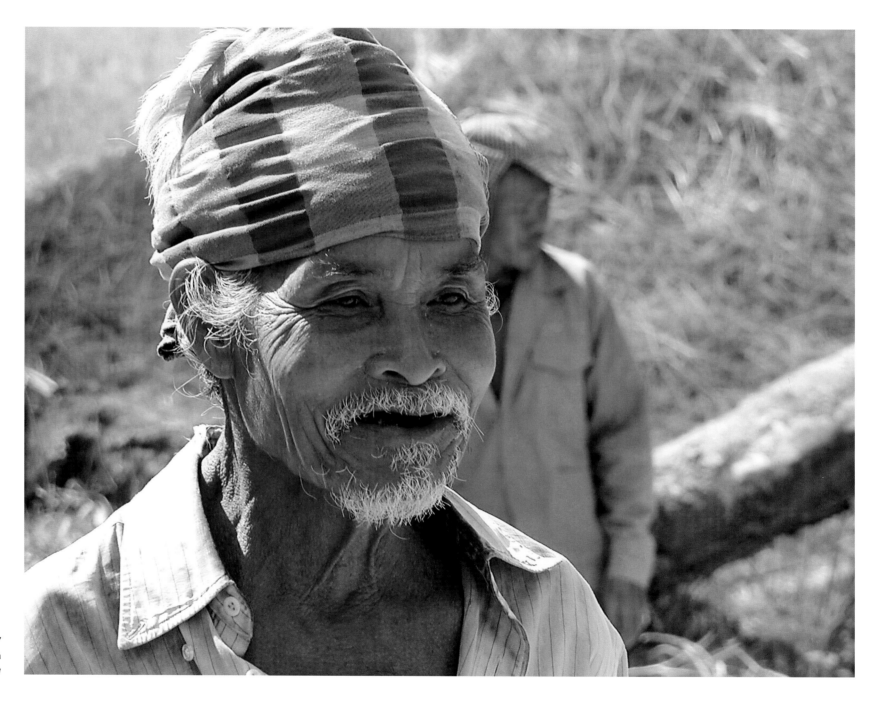

"Years of Experience"
2002 Faculty/Staff Honorable Mention
Philip Durst, *Thailand, 2001*

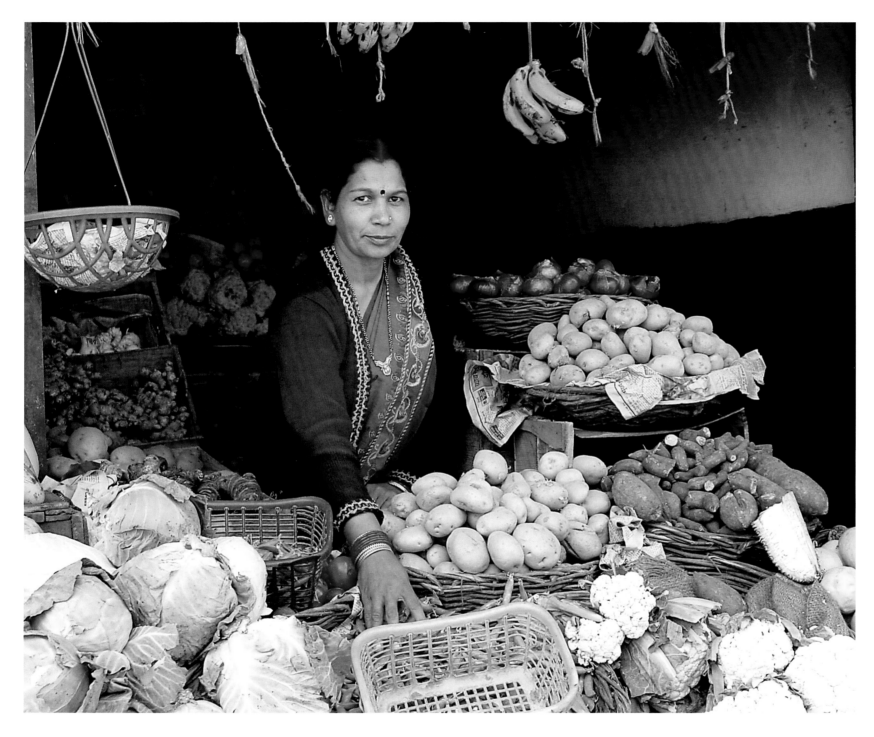

Each spring MSU sponsors a study abroad semester program in India. As part of the program we place students in internship sites in the high Himalayan region of Northern India. To monitor the students, my colleagues from Delhi and I travel the rough country roads to visit their sites. This day, we got out of the vehicle and were stretching our legs as we walked up the main street of Bhowali greeting the vendors and taking pictures. When this picture was taken, we were just about to purchase some vegetables.

"Vegetable Vendor"
2002 Faculty/Staff Honorable Mention
Mary Andrews, *India, 2001*

On the island of Mindoro, children wait for arriving and departing ferry boat passengers to challenge their swimming and diving skills by tossing coins into the ocean. The first child to retrieve the coin gets bragging rights (and funds for a sweet treat).

"Children Diving for Coins"
2003 Faculty/Staff Second Place
Michael Kron, *Philippines, 2003*

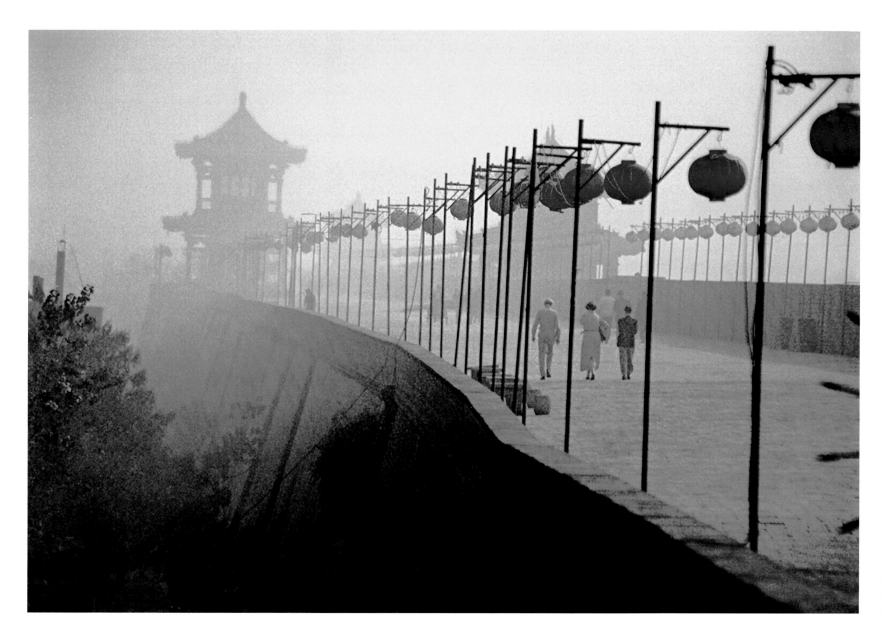

This was an early morning shot taken on the old city wall in Xian, close to where the terracotta army is located.

"City Wall"
2000 Alumni Honorable Winners
Donald Roberts, Xian, *China, 1997*

This photo was taken in Bangkok as we wandered through the grounds of the Marble Temple. The young man with the very impressive Nikon was also taking pictures, and from his growth of hair, it appeared to me that he was ending his time of service to Buddha. I thought that the contrast of camera to religion was interesting.

"Ancient Beliefs/Modern Technology"
2001 Faculty/Staff Honorable Mention
Craig Gunn, *Thailand, 2001*

This photo was taken in a village in the Indian state of Uttaranchal. This woman was attending a woman's self-help group. Although not the group leader, she seemed to command great respect from all present.

"Village Woman"
2003 Alumni Honorable Mention
Harry Andrews, *India, 2003*

This photograph was taken at the weekend market in the village of Bac Ha in northern Vietnam. The majority of people attending the market are Hmong. Whole families make the trek, primarily on foot, from their mountainside rice fields to exchange their goods and enjoy the social aspects of the event.

"A Precious Look"
2002 Student Honorable Mention
Amanda Fine, *Vietnam, 2001*

This photo was taken in a small mountain village in the Indian state of Uttaranchal. The girls pictured are master's degree students at Lady Irwin College in New Delhi. They were on a field experience looking at traditional mountain homes. This house was built almost 100 years ago.

"City Girls in Village House"
2003 Alumni Third Place
Harry Andrews, *India, 2003*

BRAC (formerly the Bangladesh Rural Advancement Committee) operates the world's largest microfinance program. Women receiving business start-up loans meet weekly to collect loan repayments, make mandatory deposits in savings accounts, and discuss the progress of their businesses. At the point that this photo was taken, they were reciting their pledges of adherence to BRAC standards of nutrition, education, child-rearing practices, sanitation, and the like.

"Village Small Business Owners Meeting"
2002 Faculty/Staff Honorable Mention
Grant Littke, *Bangladesh, 2002*

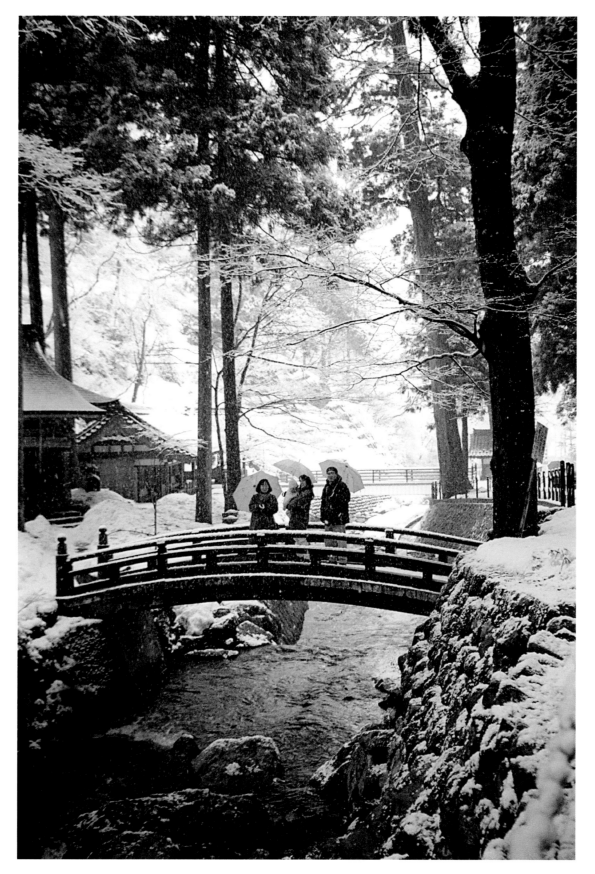

As nearly 70 percent of Japan consists of mountain ranges, the landscape is picturesque. During a trip with friends through the mountains and valleys of Fukui Prefecture, the night sky opened up, providing a fresh, wintry setting for our visit the next morning to Eihei-ji temple. Called the "temple of eternal peace," Eihei-ji was founded in 1244 and is one of Soto Zen's two head temples in Japan.

"Fresh Snowfall at Temple"
2002 Student Honorable Mention
Trent Wakenight, *Japan, 1996*

This photo was taken on a motorbike trip through northern Vietnam. At the time, we were headed to Sapa, a busy town in the mountains near the Chinese border. After a day of relentless downpour, the clouds cleared and the sun came out over this valley. This woman was by herself in the rice paddy, probably weeding.

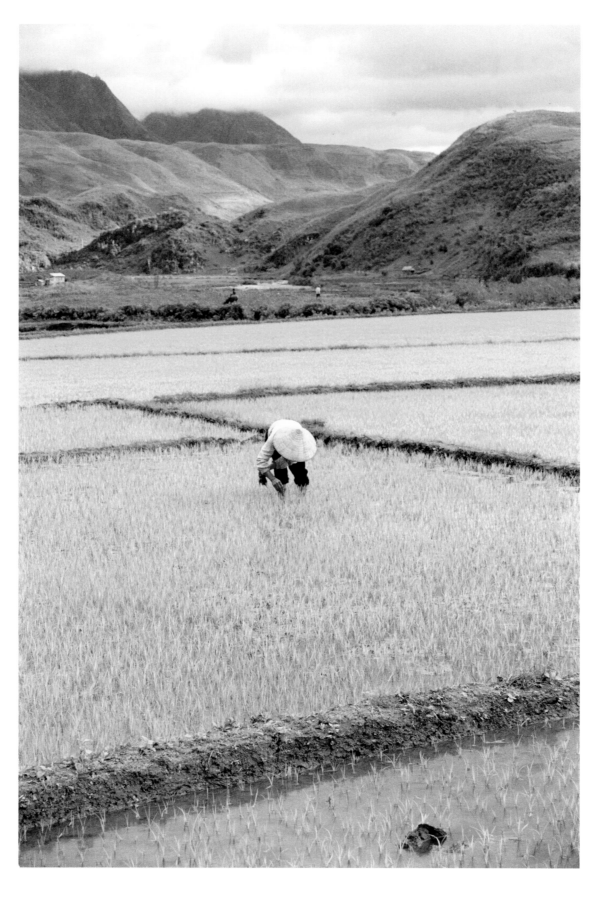

"Rice Paddy"
2003 Student Honorable Mention
Elizabeth Ostrowski, *Vietnam, 2003*

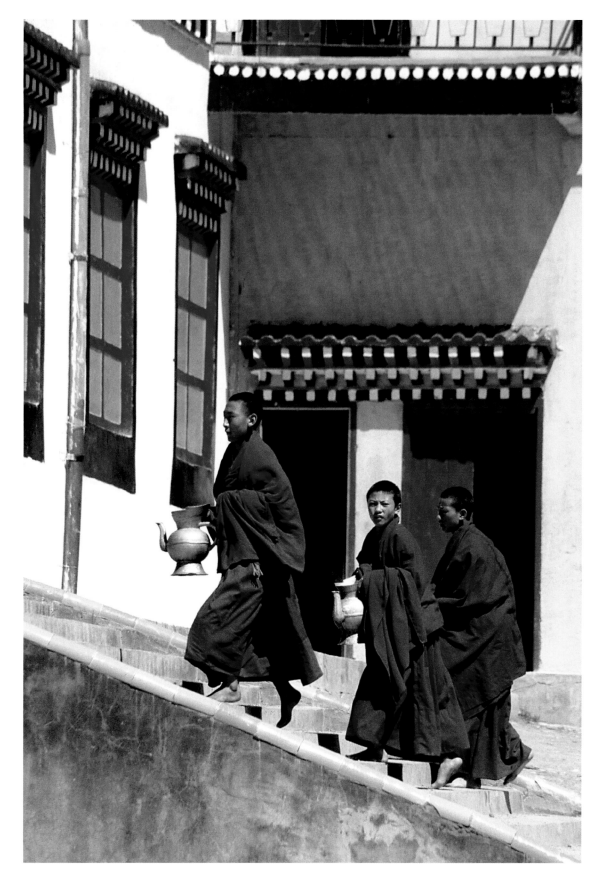

Taking a break from our giant panda research in Wolong, we set out on the long and bumpy road towards the Tibetan grasslands of Aba, Northern Sichuan. It was morning, and the Head Lama was announcing morning prayer from the roof of the temple through the sounds of a six-foot horn. This photo was taken shortly after all the shoes had collected on the front stairs of the temple, and all barefooted lamas had begun morning recitation.

"Tea for Morning Prayer"
2002 Student Third Place
Scott Bearer, *Sichuan, China, 2002*

MSU's engagement with Europe, by and large, has been different from its engagement with the other regions covered in this book, although developments since the disintegration of the Soviet Union have somewhat blurred these distinctions. Europe, like Asia, has long been a source of international students at MSU. Initially, early European students shared more cultural similarities with most of their American counterparts than Asian students of the day did, and it is likely that many domestic students felt strong ties to Europe through their ethnic roots. During more recent times, Europe has not been deemed as much "in need of" MSU's international development attention or increased academic emphasis as some other regions have been. When President Hannah announced the creation of a new Institute of Foreign Studies in 1943, Asia and South America were the main areas of emphasis, and this was in line with his predictions of increased U.S. involvement in these regions after the war.

This is not to say that MSU ignored Europe or had nothing to offer the region. There is a record of technical assistance projects throughout the twentieth century, including some focused on the recovery and reconstruction efforts after World War II. In Turkey, MSU business faculty assisted in the development of emerging business academies in four cities in the mid 1960s, and a team of education faculty worked with the Ministry of Education on improving its planning capacity during the late 1960s and early 1970s. More recent post–Cold War projects have related to issues such as health and the environment in the Balkans, local enterprise and civil society development in Hungary and Romania, urban planning curriculum development in Uzbekistan, and legal infrastructure and efforts to promote an independent press and journalism profession in several countries in the former Soviet Union.

It is also worth noting that while MSU currently has many study abroad programs in countries outside Europe, the early programs were almost all in Europe and focused on learning the languages and cultures of European countries. Although MSU has strong programs on every continent, a majority of the university's students still choose European destinations for their study abroad experiences.

European and Russian/Soviet studies at MSU began seriously, or at least explicitly, in the late 1950s with the establishment of the program for Russian and East European Studies. This emphasis was a natural result of the Cold War priorities of the times. The program was transformed into a center in 1964, and Professor William O. McCagg, an Eastern European historian, served as director for many years. While the undergraduate academic specialization in Russian and East European Studies was established early on, the companion specialization in Western European Studies did not come into being until the 1980s.

The asymmetry between emphasis on Eastern Europe and Western Europe was actually a national trend during the middle of the twentieth century. Western Europe was perceived as well-understood and was well established in the existing curricula of all major U.S. universities—indeed concerns about Eurocentrism were commonly heard. The rise of the program of European economic integration, culminating with the institutionalization of the European Union as an important economic actor, and later the end of the Cold War, led to some change in this view nationally, particularly when it became clear that there were real gaps in our understanding of Europe. The end result of these historical trends was that MSU developed substantial and broad assets in European studies, and in 1992 the separate elements of Western European Studies and Russian and East European Studies were merged to form the current Center for European and Russian Studies (CERS).

MSU has developed strong expertise in the economic and political transition patterns and challenges of Eastern Europe and the former Soviet Union. Five major international conferences on these themes have been organized by CERS since 1998. MSU hosted two of them, and the others were held in Romania, Sweden, and Turkey. These conferences have served to promote faculty development and research collaboration in areas crucial to an understanding of Eurasia. Curricular outgrowths of this broadened academic interest and expertise are evident in the expansion of language offerings to include introductory Kazakh, as well as the proposed addition of Uzbek and Turkish in the future. During the 2002–3 academic year the university launched a new cross-college Muslim Studies Initiative that promises to add strength to the existing

area studies specializations in Western European Studies and Russian and East European Studies. In support of this initiative, CERS has been heavily involved in encouraging new faculty expertise in language, culture, history, and political and economic development of Islamic societies in Central Asia and the Caucasus.

Several programs in MSU's study abroad initiative focus on economics, politics, culture, and agricultural and natural resource development in Western Europe. The variety of programs in the former Soviet Union and Eastern Europe range from transportation engineering in Volgograd, Russia, and criminal justice and democratic transition in the Ukraine, to Russian language and culture in St. Petersburg, and economic and political transition in Hungary, Romania, and Bulgaria. All told, MSU has seventy-eight distinct study abroad programs operating at present in Europe and Eurasia.

There are also seventy-five active formal linkages and major faculty research programs with institutions of higher learning in Europe and Eurasia. The growing complexity and importance of Europe and the new opportunities in the successor states to the former Soviet Union have drawn increased attention from MSU students and faculty. As MSU seeks to strengthen existing partnerships in Europe and Russia, it is also forging exciting new linkages with institutions in Georgia, Turkey, the Ukraine, Kazakhstan, Kyrġyzstan, and Uzbekistan.

MSU responded with timely expertise and vigor to many of the global challenges of the twentieth century. Of course, the work started then is not finished in many parts of the world, and the pace of the emerging challenges of globalization, socio-cultural conflict, and environmental degradation offer many new opportunities for international partnerships in teaching, research, and outreach/technical assistance. Indeed, one might expect that MSU's traditional programming strengths regarding Africa, Asia, and Latin America will need tending and enhancement in the foreseeable future, including even more faculty and student engagement. At the same time, southeastern Europe and the successor republics to the former Soviet Union seem to call out for increased attention and development support, as well.

NORMAN GRAHAM

Director, Center for European and Russian Studies

A.

B.

A. / B. After World War II, Milton Muelder (now vice president emeritus for Research Development) was heavily involved in the occupation and reconstruction of Germany. As a naval reserve lieutenant he had acted as a special consultant to Supreme Head-quarters, Allied Expeditionary Forces, in 1944 and 1945. During this period, he designed Project Carpet, which became the foundation for military governance of the non-Russian zones of post-war Germany. For this service he was awarded the Legion of Merit Award from the U.S. government. Two years later, on President Hannah's recommendation, he went on leave from MSU to return to Germany, this time to serve as deputy director of education and cultural affairs. In this position he oversaw the establishment of cultural exchange programs, was involved in other cultural reconstruction projects, and organized an eleven-nation conference on comparative education.

These two photographs were taken by Muelder in 1947, during the physical reconstruction of buildings and infrastructure. The black-and-white photograph was taken in Berlin, where debris was being removed from the site of a bombed building and bricks were being cleaned for re-use. The color photograph was taken in Nuremburg and shows the magnitude of destruction around a small church.

C. Although most of MSU's early study abroad programs emphasized foreign language study, a few had a disciplinary focus. One of these, dating back to 1970, was Comparative Criminal Justice, Criminology, and the Law, offered in England. The program, which still exists today, was created by Ralph Turner in the School of Criminal Justice. In this photograph Turner is seen posing with participants of the 1972 program.

C.

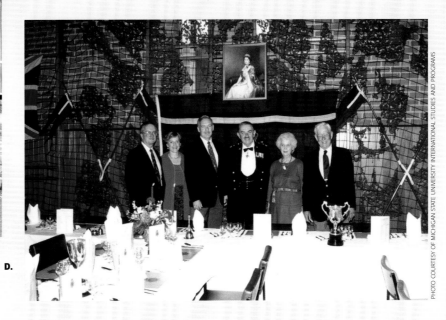

D.

D. Faculty leadership has been crucial in the development of MSU study abroad programs, and continuity in leadership has been an important component in the continued success of many long-standing programs. This photograph was taken circa 1990 and pictures the three consecutive leaders of the Comparative Criminal Justice, Criminology, and the Law program: Ralph Turner (*far right*), John Hudzik (*far left*), who led the program in the 1980s, and David Carter (*third from left*), who is the current faculty leader. This dinner was hosted by Chief Constable Charles Kelley of the Staffordshire Constabulary (*fourth from left*), who had been a partner for the field-based component of the program for many years. Anne Hudzik (*second from left*) and Arnella Turner (*second from right*) were also guests at this event.

E. / F. An important current MSU international health project is Training and Research in Environmental Health: The Balkans. Coordinated by Thomas Voice, Civil and Environmental Engineering, and David Long, Geological Sciences, the project studies the relationship between the chemistry of drinking water in certain areas of the Balkans and the prevalence of a disease known as Balkan endemic nephropathy. The work is supported by a National Institutes of Health/Fogarty International Center grant.

The first photograph was taken in Bulgaria in 2000, and depicts a team of MSU and Bulgarian researchers taking a well water sample in a village while the owner of the well looks on. In the second photograph, taken in 2004, Serbian team members are pumping a well before taking a water sample, in order to assure that the water they analyze has not sat in the well pipe.

G. / H. International Relations in Brussels-Belgium is a popular study abroad program offered by MSU's James Madison College since the late 1980s. In addition to lectures, discussions, and tutorials, the program includes field trips to important European institutions in the area. In the first photograph, taken in 1999, students sit in the information office of the European Union Commission in Brussels as they wait for a briefing by EU officials on the work of the Commission. In the second photograph, students in the 1993 program stand outside Supreme Headquarters Allied Powers Europe, located in Mons. Faculty leader Norman Graham, James Madison College, is standing on the right in the front row.

PHOTO COURTESY OF DAVID LONG

E.

PHOTO COURTESY OF DAVID LONG

F.

G.

PHOTO COURTESY OF NORMAN GRAHAM

H.

PHOTO COURTESY OF NORMAN GRAHAM

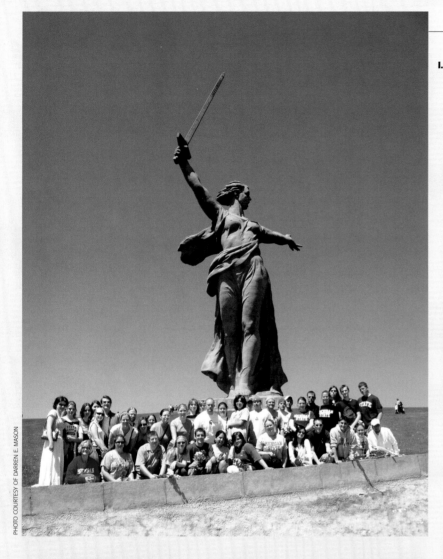

I.

J.

L.

K.

I. / J. One of the leading study abroad programs for MSU engineering majors is A Multidisciplinary Program in Russia: Engineering, Education, and Russian Language (formerly The International Practice of Civil Engineering in Volgograd—Russia). Students participating in the program come from a variety of engineering specializations, as well as from non-engineering majors, particularly Russian. Engineering courses are offered in English through the Volgograd State Architectural and Civil Engineering Academy. In addition to their academic work, students visit cultural sites in Volgograd, St. Petersburg, and Moscow. The program, which was first offered in 1998, is coordinated by Thomas Maleck, Civil Engineering, and David Prestel, Linguistics and Languages.

While on the program, students visit the statue of Mother Russia at Mamaev Hill, overlooking the city of Volgograd (formerly known as Stalingrad). The statue and surrounding memorial complex com-memorate the determination of Russia to withstand the invasion of the Germans during World War II. This photograph of program participants was taken in May 2004 by Darren Mason, Mathematics and Computer Science at Albion College, and one of the program's collaborating faculty members.

They also visit Peterhof, a set of palaces, fountains, and parks established by Peter the Great near St. Petersburg. This photograph catches students in the act of photographing an ornately decorated staircase in the Great Palace. It was taken by Evgenij Lebed, a Russian who worked for the program.

K. In 2003 Norman Graham, director of the Center for European and Russian Studies, visited Koç University in Istanbul to lay the groundwork for a collaboratively organized 2005 conference on Beyond Radical Islam. This photograph was one of several he took while on the campus.

L. In October 1995, MSU's Institute for Public Policy and Social Research and the Center for International Studies at Tomsk State University in Siberia were collaborating on the Leadership in Siberia Program sponsored by the U.S. Information Service. The purpose of the program was to provide leadership training for elected officials and administrators from the Tomsk Duma (legislative) and Oblast (state) government administration, as well as leaders of local social service programs in the region. This photograph was taken at a community development restoration site. Among those pictured are Marilyn Flynn, Social Work; Richard Hula, Political Science; John Hudzik, Criminal Justice and associate dean of Social Science; Lynn Jondahl and William Snow, IPPSR's Michigan Political Leadership Program; and Lena Raskolnikov, graduate student in Social Work.

M. Students in the 2002 Environmental Planning and Management in Europe study abroad program negotiate stepping-stones across the water at the Keukenhof Garden flower exhibition. The exhibition takes place in a park located on the grounds of a fourteenth-century estate near Lisse in northwest Holland. This photograph was taken by the program's faculty leader, Gerhardus Schultink, Community, Agriculture, Recreation, and Resource Studies. According to Schultink, the garden features the high cash products that help make Holland, with a land area less than one-third the size of Michigan's, one of the largest exporters of agricultural products in the world.

N. Turkey: An Emerging Market was the theme of an MBA study tour sponsored by MSU's Eli Broad Graduate School of Management in May 1998. Based in Istanbul, students spent ten intensive days doing academic work, learning about Turkish culture and meeting with business leaders, government officials, and educators. In this photograph, the group is visiting a Tofas/Fiat car manufacturing plant. The study tour was led by S. Tamer Cavusgil, founding executive director of MSU's Center for International Business Education and Research, and Harold Sollenberger, associate dean of the college.

O. Patty Peek, Nursing, has worked in several countries on medical mission teams that focus on community development. This photograph was taken in the village of Mukachevo in the Carpathian Mountain region during one of several such trips she has led to the Ukraine. Peek is holding a Romani child in a local medical clinic. The most recent project she has been involved in there focuses on the detection and treatment of tuberculosis. Due to the fact that most of Peek's courses are taught online, she is able to lead medical outreach teams two or three times per year. This photograph was taken by Charlie Gano, a member of Peek's team in 2000.

M.

N.

O.

This was my first trip abroad. As we walked through the town of Siena and I passed this street, it made a beautiful picture, so I took it.

"Siena Morning"
1999 Alumni Second Place
Bethany Roberts, *Italy, 1998*

It was not our intention to observe the annual Costume Festival in Arles, because we did not know of its existence. In fact, we had meant to arrive a day earlier, but, due to a series of train delays, I had the opportunity to take this photograph while the whole town was outfitted in traditional Provincial clothing. It was truly *bon chance*.

"Petite Fille" (Little Girl)
2002 Student Honorable Mention
Amber Luttig, *France, 2002*

I took this photo one afternoon after class, when I went to see the nearly deserted St. Gatien Cathedral in Tours, France. Halfway up a staircase in the cathedral's courtyard, I glanced out an arched window to see this dramatic gargoyle, framed against the cathedral's two towers.

"In the Cathedral Courtyard"
2003 Student Third Place
Janelle Shane, *France, 2003*

A woman takes home some fresh meat from the market in Mirande, France.

"Dinner"
2002 Faculty/Staff Honorable Mention
Antoinette WinklerPrins, *France, 1983*

I first visited the Aran Islands in 1998 while hosting the April 1998 Alumni College in Ireland travel/study program for the MSU Alumni Association. Horse drawn traps are used by tourists to see the islands. In the background, Celtic crosses mark a graveyard and the dry-stone walls (timber is scarce on the islands) mark property lines and enclosures for farm animals.

"Horse Drawn Trap on Inis Mór"
1999 Alumni Third Place
Louise Cooley, *Aran Islands, Ireland, 1998*

This photo was taken in Lystvianka, Russia, on the edge of Lake Baikal. I stopped off in the town for a couple of days while taking the Trans-Siberian Express from Beijing to Moscow. We went for a walk in the evening and saw this young girl watching the rare sight of foreigners walking through the village.

"Pensive"
2001 Student Honorable Mention
Bronwyn Irwin, *Russia, 1998*

We were given a private show by a local Flamenco group in a long vaulted room beneath Ubeda's City Hall.

"Flamenco Dancer"
1999 Alumni Honorable Mention
Donald F. Roberts, *Ubeda, Spain, 1999*

This photo was taken on a day-long bicycle ride with my family through the French countryside outside of Beaune in Burgundy. We were in the region visiting eco-museums in follow-up to a previous study trip sponsored by the French American Foundation.

"Sunflowers"
2003 Faculty/Staff Honorable Mention
Marsha MacDowell, *France, 2003*

This photo was taken of the north bank of the Porto River in Porto, Portugal. As with most photos (I think) some element of light, subject, and composition led me to take this picture. I was drawn to the mélange of colors that were so vibrant, some reflecting off the river that is not part of this image, the contrast between the horizontality of the boat and the verticality of the houses that extended considerably up the hill, and lastly, the light which created some shadowing on the buildings that is not reflected in this image very well.

"Porto"
2002 Faculty/Staff Honorable Mention
Vince WinklerPrins, *Portugal, 2000*

This picture was taken in Lake Como, Italy, while I was on sabbatical. I was walking on a morning trip, and I spotted this woman carrying a bale of hay with her husband watching her. Thought it was kind of unusual, but not in Italy.

"Italian Working Woman"
2003 Faculty/Staff Honorable Mention
Richard Merritt, *Italy, 1986*

This photo was taken after a university Vespers service. Both the faculty and students attended the service dressed in academic garb.

"After Vespers: Erudites and Attendants"
2001 Alumni Third Place
Linda Roberts, *England, 1995*

This picture looks down from atop a glacier in central Iceland after an August snow fall. The tiny silhouette, a fellow volunteer on the research project which brought me to the desolate island, had fallen behind the group in the long climb up.

"Isolation in Iceland"
2003 Student Honorable Mention
Heather Aschoff, *Iceland, 2002*

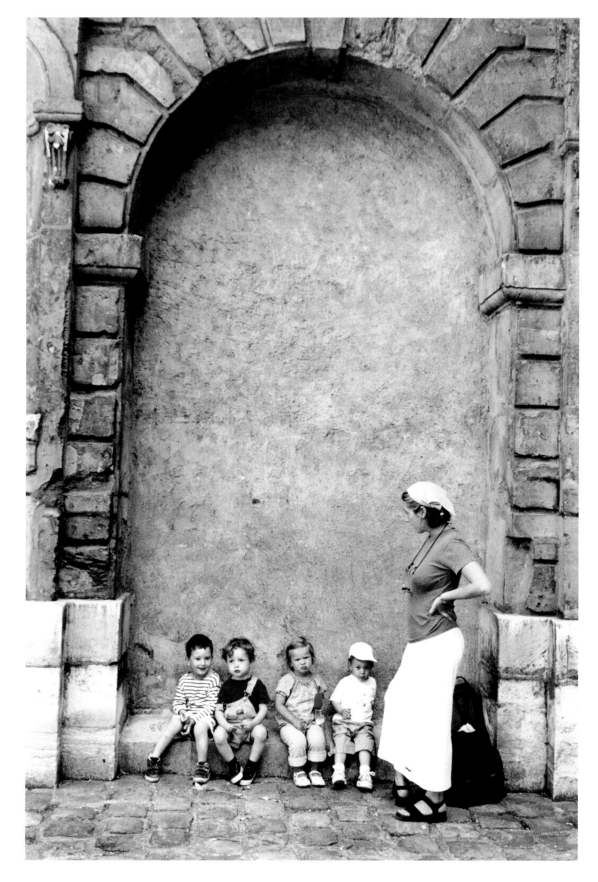

What caught the attention of my lens in Paris included this shot of a nanny and her four infants just outside of the Place des Vosges. The children's clothing, the nanny's posture, and the stone arch that framed them as if to say, "La voilá"—here it is—signified the momentary, harmonious collision of a rich French history I had learned about in an Ohio classroom and the daily French life that I was coming to know.

"Culture Overarches"
2003 Student First Place
Liz Farina, *France, 2000*

While touring Italy in September 1998, I took photographs along the way to reflect the people and the culture. This photo, taken from the top of the Scalinata di Spagna (Spanish Steps) in Rome, is a scene of painters at work "Painting Rome" during late afternoon.

"Painting Rome"
1999 Faculty/Staff Honorable Mention
Lori Hosington, *Rome, Italy, 1998*

On a trip to London, we had visited several cathedrals. This was actually the cathedral in Salisbury, England. Since all the ceilings were beautiful, I was looking for a different slant on it, and so this is the way I photographed it.

"Cathedral Ceiling"
2002 Alumni First Place
Bethany Roberts, *England, 2000*

MSU Global Focus 1999

FIRST PLACE STUDENT

Matthew Geisler

"Planting, Laughing, Smiling," *Kagbeni, Nepal, 1999*

PRIZE: Round-trip ticket to anywhere in the continental United States

SPONSOR: Classic Travel, Okemos, Michigan

SECOND PLACE STUDENT

Marie MacGillis

"Boy in Venice," *Venice, Italy, 1998*

PRIZE: Tamron Zoom Lens

SPONSOR: The Camera Shop, Lansing, Michigan

THIRD PLACE STUDENT

Ishan Girdhar

"Mountain High," *Nepal, 1999*

PRIZE: Decorated Porcelain Plate from Egypt

SPONSOR: Siham "Sue" Idris of Travel Galleria, Okemos, Michigan

HONORABLE MENTION, STUDENT

Alethia Calagias

"Samaria Gorge," *Crete, Greece, 1999*

PRIZE: MSU T-shirt

SPONSOR: MSU Alumni Association

Alethia Calagias

"Villagers of Eleftherna," *Crete, Greece, 1999*

PRIZE: MSU T-shirt

SPONSOR: MSU Alumni Association

Todd Gormley

"Backyard in Budapest," *Hungary, 1999*

PRIZE: MSU sweatshirt

SPONSOR: Student Book Store, MSU

Brian Grant

"North Sea Winds," *St. Andrew, Scotland, 1998*

PRIZE: MSU sweatshirt

SPONSOR: International Studies and Programs, MSU

Erin Hill

"Moroccan Girl," *1999*

PRIZE: MSU T-shirt

SPONSOR: MSU Alumni Association

Erin Hill

"Moroccan Children," *1999*

PRIZE: MSU T-shirt

SPONSOR: MSU Alumni Association

Elizabeth J. Kendall

"Cross of Faith," *Donegal, Ireland, 1999*

PRIZE: MSU travel bag

SPONSOR: MSU Alumni Association

Glenn J. Kerr

"Hillside Cultivation—Making a Jhum," *Meghayala State, India, 1997*

PRIZE: MSU sweatshirt

SPONSOR: International Studies and Programs, MSU

Nicole Mashni

"Jerusalem's Window," *Jerusalem, Israel, 1999*

PRIZE: MSU mug and cover

SPONSOR: MSU Alumni Association

FIRST PLACE FACULTY/STAFF

Ed Ingraham

"Academic Abstract," *Monash University, Melbourne, Australia, 1999*

PRIZE: One-week stay at Sea Pines Plantation, Hilton Head Island, S.C.

SPONSOR: Ruth Clark, Clark Travel, Haslett, Michigan

SECOND PLACE FACULTY/STAFF

Michael Kron

"Untitled," *Galapagos Islands, Ecuador, 1999*

PRIZE: Photography tutorial

SPONSOR: Peter Glendinning, MSU Department of Art

THIRD PLACE FACULTY/STAFF

Mikala Keating

"Big Buddha," *Kamakura, Japan, 1996*

PRIZE: Photography tutorial

SPONSOR: Darcy Greene, MSU School of Journalism

The complete set of MSU Global Focus winners can be viewed in the online gallery at *http://www.isp.msu.edu/photocontest*

James Detjen

"Uluru at Dusk," *Australia, 1999*

PRIZE: *The Illustrated History of the State of Michigan*

SPONSOR: MSU Alumni Association

Andrea Funkhouser

"Ecological Study of Costa Rican Rain Forest," *Costa Rica, 1998*

PRIZE: MSU sweatshirt

SPONSOR: International Studies and Programs, MSU

John Funkhouser

"Engulfed in Balinese Music," *Bali, Indonesia, 1996*

PRIZE: MSU sweatshirt

SPONSOR: International Studies and Programs, MSU

Lori Hoisington

"Painting Rome," *Rome, Italy, 1998*

PRIZE: MSU travel bag

SPONSOR: MSU Alumni Association

Lori Hoisington

"Gothic Glimpses at Chartres Cathedral"

PRIZE: MSU travel bag

SPONSOR: MSU Alumni Association

Michael Morris

"Decorated Exterior," *Korea, 1998*

PRIZE: MSU mug and cover

SPONSOR: MSU Alumni Association

FIRST PLACE ALUMNI

Richard McDonald

"Market Child," *Chichicastenango, Guatemala, 1999*

PRIZE: Tamron zoom lens

SPONSOR: Castle Photo, Lansing, Michigan

SECOND PLACE ALUMNI

Bethany Roberts

"Siena Morning," *Italy, 1998*

PRIZE: Tamron teleconverter

SPONSOR: Tamron Industries, Farmingdale, New York

THIRD PLACE ALUMNI

Louise Cooley

"Horse Drawn Trap on Inis Mór," *Aran Islands, Ireland, 1998*

PRIZE: $100 gift certificate

SPONSOR: Hankins Gallery, East Lansing, Michigan

HONORABLE MENTION, ALUMNI

Richard McDonald

"Pet Happiness," *Chichicastenango, Guatemala, 1999*

PRIZE: Already awarded for first place

Donald F. Roberts

"Boy on Street," *Ubeda, Spain, 1999*

PRIZE: MSU hat

SPONSOR: International Studies and Programs, MSU

Donald F. Roberts

"Flamenco Dancer," *Ubeda, Spain, 1999*

PRIZE: MSU hat

SPONSOR: International Studies and Programs, MSU

Kathleen Nowicki Schwartz

"Global Market," *Munich, Germany, 1998*

PRIZE: MSU sweatshirt

SPONSOR: International Studies and Programs, MSU

MSU Global Focus 2000

FIRST PLACE STUDENT

Jonathan Schulz

"Buena Vista (The Mountain One)," *Cocotitlán, Mexico, 2000*

PRIZE: Round-trip ticket to anywhere in the continental United States

SPONSOR: Classic Travel, Okemos, Michigan

SECOND PLACE STUDENT

Robert Gorski

"Woman's Work," *Dhunche, Nepal, 2000*

PRIZE: $100 gift certificate

SPONSOR: Hankins Gallery, East Lansing, Michigan

THIRD PLACE STUDENT

Elizabeth Berg

"Self Portrait," *Table Mountain, Cape Town, South Africa, 2000*

PRIZE: Dinner for two

SPONSOR: The State Room, Kellogg Center, MSU

HONORABLE MENTION, STUDENT

Will Brick

"Window," *Dover, England, 2000*

PRIZE: $25 gift certificate

SPONSOR: Wharton Center for the Performing Arts, MSU

David Dilworth

"Man in the Mountain," *Annapurna Circuit, Nepal, 2000*

PRIZE: $50 gift certificate

SPONSOR: Saper Galleries, East Lansing, Michigan

Betsy Evans

"Cinque Terre," *Manarola, Italy, 2000*

PRIZE: $25 gift certificate

SPONSOR: Puffins Pastry Shop, MSU

Bronwyn Irwin
"Cestas y Veduras," *Sucre, Bolivia, 1999*
PRIZE: MSU sweatshirt
SPONSOR: International Studies and Programs,
 MSU

Bronwyn Irwin
"Parched," *Sossuvliet, Nambia, 1999*
PRIZE: MSU sweatshirt
SPONSOR: International Studies and Programs,
 MSU

Lisa Molloy
"Bushmeat on Congo Forest Road Side," *Republic
 of Congo, Brazzaville, 2000*
PRIZE: MSU sweatshirt
SPONSOR: MSU Alumni Association

Richard Smith
"The Old and the New," *Goroka, Papua New
 Guinea, 1997*
PRIZE: MSU sweatshirt
SPONSOR: International Studies and Programs,
 MSU

FIRST PLACE FACULTY/STAFF
John M. Hunter
"Interior, National Cathedral," *Brasilia, Brazil, 1970*
PRIZE: One-week stay, Sea Pines Plantation, Hilton
 Head Island, S.C.
SPONSOR: Clark Travel Connection, Haslett,
 Michigan

SECOND PLACE FACULTY/STAFF
Andrea Funkhouser
"Taj Mahal—A Different Perspective," *Agra, India,
 1997*
PRIZE: Overnight stay for two
SPONSOR: Brook Lodge, MSU, Augusta, Michigan

THIRD PLACE FACULTY/STAFF
Antoinette WinklerPrins
"Living with the Flood," *Amazon River flood plain,
 Brazil, 1996*
PRIZE: Four tickets to a family show
SPONSOR: Jack Breslin Student Events Center,
 MSU

HONORABLE MENTION, FACULTY/STAFF
Mary Andrews
"Brothers," *Lake Volta, Ghana, 2000*
PRIZE: MSU T-shirt
SPONSOR: MSU Alumni Association

Freda Cruél
"Native Walis' Brooms," *Baguio, Philippines, 1997*
PRIZE: MSU sweatshirt
SPONSOR: International Studies and Programs,
 MSU

Freda Cruél
"Children Working Strawberry Fields," *Baguio,
 Philippines, 1997*
PRIZE: MSU sweatshirt
SPONSOR: International Studies and Programs,
 MSU

Talbott Huey
"Roman Ruins and Modern Art," *Jerusalem, Israel,
 2000*
PRIZE: 8" × 10" enlargement with wood frame
SPONSOR: Ritz Camera Centers

Prita Meier
"The Art of Henna I," *Lamu, Kenya, 2000*
PRIZE: MSU sweatshirt
SPONSOR: International Studies and Programs,
 MSU

FIRST PLACE ALUMNI
David Danek
"Asian Agriculture," *Yunnan, China, 2000*
PRIZE: $150 of color film
SPONSOR: Castle Photo, Lansing, Michigan

SECOND PLACE ALUMNI
Linda Roberts
"Quijote's Windmills," *Consuegra, Spain, 1998*
PRIZE: Wide-angle lens
SPONSOR: The Camera Shop of Lansing, Lansing,
 Michigan

THIRD PLACE ALUMNI
Pamela Luttig
"Camel at the Pyramid of Zoser," *Saqqara, Egypt,
 2000*
PRIZE: MSU hooded jacket
SPONSOR: Follet's MSU Bookstore, East Lansing,
 Michigan

HONORABLE MENTION, ALUMNI
Pamela Kilgore
"Quiet Friday," *Pratsgatan, Stockholm, Sweden,
 2000*
PRIZE: MSU Sweatshirt
SPONSOR: MSU Alumni Association

Donald F. Roberts
"Tower of London," *London, England, 2000*
PRIZE: MSU T-shirt
SPONSOR: MSU Alumni Association

Donald F. Roberts
"City Wall," *Xian, China, 1997*
PRIZE: MSU T-shirt
SPONSOR: MSU Alumni Association

Donald F. Roberts
"Parade Rehearsal," *Shanghai, China, 1997*
PRIZE: MSU T-shirt
SPONSOR: MSU Alumni Association

MSU Global Focus 2001

FIRST PLACE STUDENT
Brian VanEerden
"Stonehenge at Dawn," *England, 2001*
PRIZE: One free round-trip ticket to anywhere in
the continental United States
SPONSOR: Classic Travel, Okemos, Michigan

SECOND PLACE STUDENT
Wanda Lau
"Entryway," *China, 2001*
PRIZE: $100 gift certificate
SPONSOR: Hankins Gallery, East Lansing, Michigan

THIRD PLACE STUDENT
Anne Engh
"Under African Skies," *Kenya, 2000*
PRIZE: $50 gift certificate
SPONSOR: Saper Galleries and Custom Framing,
East Lansing, Michigan

HONORABLE MENTION, STUDENT
Shaun Bailey
"Carousel on the Shore," *England, 2001*
PRIZE: MSU sweatshirt
SPONSOR: International Studies and Programs,
MSU

Scott Bearer
"Wuyipeng Giant Panda Camp," *China, 2000*
PRIZE: MSU sweatshirt
SPONSOR: International Studies and Programs,
MSU

Erika Dattero
"Beyond the Wall," *Scotland, 2001*
PRIZE: 8" × 10" big print digital enlargement with
wood frame
SPONSOR: Ritz Camera Centers

Rob Gorski
"La Música de la Maya," *Guatemala, 2000*
PRIZE: MSU sweatshirt
SPONSOR: International Studies and Programs,
MSU

Jordon Harris
"Los Carneros" (The Sheep), *Ecuador, 2001*
PRIZE: Dinner for two
SPONSOR: The State Room, Kellogg Center, MSU

Jordon Harris
"El Camino," *Ecuador, 2001*
PRIZE: Dinner for two
SPONSOR: The State Room, Kellogg Center, MSU

Bronwyn Irwin
"Pensive," *Russia, 1998*
PRIZE: $50 Wharton Dollars
SPONSOR: Wharton Center for Performing Arts,
MSU

Kyle Martin
"Hide and Go Seek," *Haiti, 2001*
PRIZE: MSU sweatshirt
SPONSOR: International Studies and Programs,
MSU

Sarah Stella
"#17 Via della Lungara," *Italy, 2001*
PRIZE: MSU sweatshirt
SPONSOR: International Studies and Programs,
MSU

Izumi Yamashita
"A Restaurant in Rapallo," *Italy, 1993*
PRIZE: Four tickets to a family show
SPONSOR: Jack Breslin Student Events Center,
MSU

FIRST PLACE FACULTY/STAFF
Vincent WinklerPrins
"The School Outing," *Bath, England, 1999*
PRIZE: One-week stay at Sea Pines Plantation,
Hilton Head Island, S.C.
SPONSOR: Ruth Clark, Clark Travel Connection

SECOND PLACE FACULTY/STAFF
Thomas Stanulis
"Haircut," *China, 1998*
PRIZE: Overnight stay for two
SPONSOR: Brook Lodge, MSU, Augusta, Michigan

THIRD PLACE FACULTY/STAFF
John Funkhouser
"The Burden of Another Day," *Peru, 2001*
PRIZE: MSU hooded jacket
SPONSOR: Follet's MSU Bookstore

HONORABLE MENTION, FACULTY/STAFF
Tracy Dobson
"You're Curious? Well, So Am I," *Kenya, 2001*
PRIZE: $50 gift certificate
SPONSOR: Puffins Bakery, Brody Hall, MSU

Andrea Funkhouser
"In Awe of Dinosaur Tracks," *Bolivia, 2001*
PRIZE: MSU sweatshirt
SPONSOR: MSU Alumni Association

Craig Gunn
"Ancient Beliefs/Modern Technology," *Thailand,
2001*
PRIZE: MSU sweatshirt
SPONSOR: MSU Alumni Association

Michael Miller
"Dust to Dust—Gone but Not Forgotten,"
Bamiyan, Afghanistan, 1977
PRIZE: None (ISP employee)

Thomas Stanulis
"Reading the Paper," *China, 1998*
PRIZE: Already awarded for second place

Thomas Stanulis
"Hong Kong," *Hong Kong, 1998*
PRIZE: Already awarded for second place

Vincent WinklerPrins
"Untitled," *Alcobaca, Portugal, 2000*
PRIZE: Already awarded for first place

FIRST PLACE ALUMNI
Linda Roberts
"Boudhanath Stupa," *Nepal, 2001*
PRIZE: Wide-angle lens
SPONSOR: The Camera Shop, Lansing, Michigan

SECOND PLACE ALUMNI
Bethany Roberts
"Bicycles at City Hall," *Netherlands, 2001*
PRIZE: $150 of color film
SPONSOR: David Hopkins of Castle Photo,
 Lansing, Michigan

THIRD PLACE ALUMNI
Linda Roberts
"After Vespers: Erudites and Attendants," *England,
 1995*
PRIZE: Already awarded for first place

HONORABLE MENTION, ALUMNI
David Danek
"Enlightenment," *Thailand, 2000*
PRIZE: MSU sweatshirt
SPONSOR: MSU Alumni Association

David Danek
"Serenity," *Thailand, 2000*
PRIZE: MSU sweatshirt
SPONSOR: MSU Alumni Association

Michael DeYoung
"January Harvest," *Malawi, 2001*
PRIZE: MSU sweatshirt
SPONSOR: MSU Alumni Association

Pamela Luttig
"Old Cairo Street," *Egypt, 2001*
PRIZE: MSU sweatshirt
SPONSOR: MSU Alumni Association

MSU Global Focus 2002
FIRST PLACE STUDENT
Liz Farina
"Nonna Hubbard's Errand," *Bologna, Italy, 2001*
PRIZE: One round-trip airline ticket to anywhere
 in the continental United States
SPONSOR: Classic Travel, Okemos, Michigan

SECOND PLACE STUDENT
Jessica Mills
"Eager Minds," *Zimbabwe, 1998*
PRIZE: $100 gift certificate
SPONSOR: Hankins Gallery, East Lansing, Michigan

THIRD PLACE STUDENT
Scott Bearer
"Tea for Morning Prayer," *Sichuan, China, 2002*
PRIZE: $150 gift certificate for camera repair
SPONSOR: Midwest Camera Repair

HONORABLE MENTION, STUDENT
Scott Bearer
"Prayer Wheels in Darkness," *China, 2002*
PRIZE: Already awarded for third place

Heather Costello
"School's Out in Havana," *Cuba, 2001*
PRIZE: MSU sweatshirt
SPONSOR: International Studies and Programs,
 MSU

Oliver Dragicevic
"In Search of Lost Time at Musée d'Orsay," *France,
 2002*
PRIZE: MSU sweatshirt
SPONSOR: International Studies and Programs,
 MSU

Amanda Fine
"A Precious Look," *Vietnam, 2001*
PRIZE: MSU sweatshirt
SPONSOR: International Studies and Programs,
 MSU

Amanda First
"Trinkets of Venice," *Italy, 2002*
PRIZE: 8" × 10" digital enlargement with wood
 frame
SPONSOR: Ritz Camera Centers

Kristin Janka-Millar
"Inca Walls," *Peru, 1991*
PRIZE: MSU sweatshirt
SPONSOR: International Studies and Programs,
 MSU

Amber Luttig
"Petite Fille" (Little Girl), *France, 2002*
PRIZE: MSU sweatshirt
SPONSOR: International Studies and Programs,
 MSU

Elizabeth Pfaff
"Caution!," *Japan, 2002*
PRIZE: $50 gift certificate
SPONSOR: Puffin's Pastry Shop, Brody Hall, MSU

Natalia Ruiz-Rubio
"Woman Carrying Water," *Marrakech, Morocco,
 1998*
PRIZE: MSU sweatshirt
SPONSOR: International Studies and Programs,
 MSU

Trent Wakenight
"Fresh Snowfall at Temple," *Japan, 1996*
PRIZE: MSU sweatshirt
SPONSOR: International Studies and Programs,
MSU

FIRST PLACE FACULTY/STAFF
John Funkhouser
"Friends Sharing a Peaceful Moment," *Tanzania, 2002*
PRIZE: $360 gift certificate for developing prints
SPONSOR: Love Photo Lab

SECOND PLACE FACULTY/STAFF
Kirsten Khire
"Prema's Lookout—Franz Josef Glacier," *New Zealand, 2000*
PRIZE: Dinner for two
SPONSOR: The State Room, Kellogg Center, MSU

THIRD PLACE FACULTY/STAFF
Joy Campbell
"The Button Man," *Morocco, 1998*
PRIZE: $100 gift certificate
SPONSOR: Saper Galleries and Custom Framing,
East Lansing, Michigan

HONORABLE MENTION, FACULTY/STAFF
Mary Andrews
"Vegetable Vender," *India, 2001*
PRIZE: $100 gift certificate
SPONSOR: Carriage Travel, Inc.

Philip Durst
"Years of Experience," *Thailand, 2001*
PRIZE: Four tickets to a family show
SPONSOR: Jack Breslin Students Event Center,
MSU

John Funkhouser
"Maasai Family," *Tanzania, 2002*
PRIZE: Already awarded for first place

Grant Littke
"Village Small Business Owners Meeting," *Bangladesh, 2002*
PRIZE: $50 Wharton Dollars
SPONSOR: Wharton Center for Performing Arts,
MSU

Vincent WinklerPrins
"Porto," *Portugal, 2000*
PRIZE: MSU sweatshirt
SPONSOR: MSU Alumni Association

Antoinette WinklerPrins
"Dinner," *France, 1983*
PRIZE: MSU sweatshirt
SPONSOR: MSU Alumni Association

FIRST PLACE ALUMNI
Bethany Roberts
"Cathedral Ceiling," *England, 2000*
PRIZE: $150 in color film
SPONSOR: Castle Photo, Lansing, Michigan

SECOND PLACE ALUMNI
Linda Roberts
"La Mañanera," *Peru, 2002*
PRIZE: Overnight stay for two
SPONSOR: Brook Lodge, MSU, Augusta, Michigan

THIRD PLACE ALUMNI
Donald F. Roberts
"Chips," *England, 2000*
PRIZE: Electronic flash for electronic camera
SPONSOR: Camera Shop of Lansing, Lansing,
Michigan

HONORABLE MENTION, ALUMNI
Philip Babcock
"Tradition," *England, 2001*
PRIZE: MSU sweatshirt
SPONSOR: MSU Alumni Association

Shaun Bailey
"Grasmere Religious Parade," *England, 2001*
PRIZE: MSU sweatshirt
SPONSOR: MSU Alumni Association

Beth Brezinski
"London Calling," *England, 1991*
PRIZE: MSU sweatshirt
PRIZE sponsor: MSU Alumni Association

Robert Glew
"New Friend From Kouyewa," *Niger, 2002*
PRIZE: MSU hooded jacket
SPONSOR: Follett's MSU Bookstore

Elizabeth Huff
"Tibetan Prayer Flags," *India, 2002*
PRIZE: MSU sweatshirt
SPONSOR: MSU Alumni Association

Bethany Roberts
"Palace at the Alhambra," *Spain, 1999*
PRIZE: Already awarded for first place

MSU Global Focus 2003
FIRST PLACE STUDENT
Liz Farina
"Culture Overarches," *France, 2000*
PRIZE: One round-trip airline ticket to anywhere
in the continental United States
SPONSOR: Classic Travel, Okemos, Michigan

SECOND PLACE STUDENT

Jacob Baldwin

"First Communion," *Ireland, 2003*

PRIZE: Electronic flash for electronic camera

SPONSOR: The Camera Shop of Lansing, Lansing, Michigan

THIRD PLACE STUDENT

Janelle Shane

"In the Cathedral Courtyard," *France, 2003*

PRIZE: $100 gift certificate

SPONSOR: Hankins Gallery, East Lansing, Michigan

HONORABLE MENTION, STUDENT

Heather Aschoff

"Isolation in Iceland," *Iceland, 2002*

PRIZE: MSU sweatshirt

SPONSOR: International Studies and Programs, MSU

Henrique Bertulani

"Sentinel," *Egypt, 2003*

PRIZE: MSU sweatshirt

SPONSOR: International Studies and Programs, MSU

Dmitriy Bryndin

"Old Ladies of St. Petersburg," *Russia, 2003*

PRIZE: MSU sweatshirt

SPONSOR: International Studies and Programs, MSU

Stephanie Dloniak

"Acacia Sunrise," *Kenya, 2003*

PRIZE: MSU sweatshirt

SPONSOR: International Studies and Programs, MSU

Elizabeth Ostrowski

"Rice Paddy," *Vietnam, 2003*

PRIZE: MSU sweatshirt

SPONSOR: International Studies and Programs, MSU

Leslie Richards

"La Familia Unida," *Mexico, 2003*

PRIZE: $50 gift certificate

SPONSOR: Puffin's Pastry Shop

Clint Spaulding

"Staring Through Time's Window," *England, 2003*

PRIZE: $50 Wharton Dollars

SPONSOR: Wharton Center for Performing Arts, MSU

Cuizhen Wang

"Net," *Thailand, 2000*

PRIZE: $50 gift certificatee

SPONSOR: Spartan Bookstore, MSU

Cynthia Wei

"Modern Times, Ancient Places," *Taiwan, 1998*

PRIZE: MSU sweatshirt

SPONSOR: International Studies and Programs, MSU

FIRST PLACE FACULTY/STAFF

Philip Durst

"Panama Smile," *Panama, 2003*

PRIZE: Overnight stay for two

SPONSOR: Brook Lodge, MSU, Augusta, Michigan

SECOND PLACE FACULTY/STAFF

Michael Kron

"Children Diving for Coins," *Philippines, 2003*

PRIZE: Dinner for two

SPONSOR: The State Room, Kellogg Center, MSU

THIRD PLACE FACULTY/STAFF

Joy Campbell

"Pick a Jar, Any Jar," *Morocco, 1999*

PRIZE: $150 of color film

SPONSOR: Castle Photo

HONORABLE MENTION, FACULTY/STAFF

Marit Dewhurst

"Untitled," *Senegal, 2003*

PRIZE: MSU hooded sweatshirt

SPONSOR: International Studies and Programs, MSU

Andrea Funkhouser

"Vultures Nesting at Sunset," *Kenya, 2001*

PRIZE: MSU sweatshirt

SPONSOR: International Studies and Programs, MSU

Marsha MacDowell

"Sunflowers," *France, 2003*

PRIZE: MSU sweatshirt

SPONSOR: International Studies and Programs, MSU

Michele Madison

"Island Houses," *Dominican Republic, 2001*

PRIZE: $150 gift certificate for camera repair

SPONSOR: Midwest Camera Repair

Richard Merritt

"Brazilian Farm Family," *Brazil, 2003*

PRIZE: MSU sweatshirt

SPONSOR: International Studies and Programs, MSU

Richard Merritt

"Italian Working Woman," *Italy, 1986*

PRIZE: MSU sweatshirt

SPONSOR: International Studies and Programs, MSU

FIRST PLACE ALUMNI
Donald F. Roberts
"Girl in Red," *China, 1997*
PRIZE: $100 gift certificate
SPONSOR: Carriage Travel, Inc.

SECOND PLACE ALUMNI
Robert Glew
"Long Walk Home," *Niger, 2002*
PRIZE: $100 gift certificate
SPONSOR: Saper Galleries and Custom Framing,
 East Lansing, Michigan

THIRD PLACE ALUMNI
Harry Andrews
"City Girls in Village House," *India, 2003*
PRIZE: Four tickets to a family show
SPONSOR: Jack Breslin Students Events Center,
 MSU

HONORABLE MENTION, ALUMNI
Harry Andrews
"Village Woman," *India, 2003*
PRIZE: Already awarded for third place

Harry Andrews
"Resting away from the Crowd," *India, 2003*
PRIZE: Already awarded for third place

Mark Horner
"Alone in the Transkei," *South Africa, 2003*
PRIZE: MSU sweatshirt
SPONSOR: MSU Alumni Association

Donald F. Roberts
"Shennong XI River #2," *China, 1997*
PRIZE: Already awarded for first place

Linda Roberts
"Meditation," *Thailand, 2003*
PRIZE: MSU sweatshirt
SPONSOR: MSU Alumni Association

MSU Global Focus Jurors, 1999–2003

MSU GLOBAL FOCUS 1999
Peter Glendinning, *MSU Department of Art and Art History*
Darcy Greene, *MSU School of Journalism*
Kim Kauffman, *Kim Kauffman Photography*

MSU GLOBAL FOCUS 2000
Bruce Fox, *MSU University Relations*
Danny Guthrie, *MSU Department of Art and Art History*
Michael Schimpf, *Professional Photographer*

MSU GLOBAL FOCUS 2001
Peter Glendinning, *MSU Department of Art and Art History*
Darcy Greene, *MSU School of Journalism*
Kim Kauffman, *Kim Kauffman Photography*

MSU GLOBAL FOCUS 2002
Howard Bossen, *MSU School of Journalism*
Roy Saper, *Saper Galleries*
Paula Stuart-Hankins, *MSU Department of Art and Art History*

MSU GLOBAL FOCUS 2003
Peter Glendinning, *MSU Department of Art and Art History*
Darcy Greene, *MSU School of Journalism*
Kim Kauffman, *Kim Kauffman Photography*